CW00659475

FASHION HOTELS

teNeues

Editor: Guy Dittrich

Editorial coordination: Katharina Feuer, Markus Mutz

Introduction: Guy Dittrich

Layout & Pre-press: Jasmina Bremer

Imaging: Jan Hausberg

Translations: CET Central European Translations
Stefanie Guim Marcé (German, Spanish)
Virginie Delavarinya-Ségard (French)
Fjona Stühler (Italian)

Produced by fusion publishing GmbH, Stuttgart . Los Angeles www.fusion-publishing.com

Published by teNeues Publishing Group

teNeues Verlag GmbH + Co. KG
Am Selder 37
47906 Kempen, Germany
Tel.: 0049-(0)21 52 916-0
Fax: 0049-(0)21 52 916-111

Press department: arehn@teneues.de
Tel: 0049-(0)21 52 916-202

teNeues International Sales Division
Speditionstr. 17
40221 Düsseldorf, Germany
Tel.: 0049-(0)211-99 45 97-0
Fax: 0049-(0)211-99 45 97-40

teNeues Publishing Company
16 West 22nd Street
New York, NY 10010, USA
Tel.: 001-212-627-9090
Fax: 001-212-627-9511

teNeues Publishing UK Ltd.
P.O. Box 402
West Byfleet
KT14 7ZF, Great Britain
Tel.: 0044-1932-403509
Fax: 0044-1932-403514

teNeues France S.A.R.L.
4, rue de Valence
75005 Paris, France
Tel.: 0033-1-55 76 62 05
Fax: 0033-1-55 76 64 19

teNeues Ibérica S.L.
c/Velázquez, 57 6.° izda.
28001 Madrid, Spain
Tel.: 0034-(0)-657 132 133

teNeues
Representative Office Italy
Via San Vittore 36/1
20123 Milan
Tel.: 0039-(0)-347-76 40 551

www.teneues.com

ISBN-10: 3-8327-9140-X
ISBN-13: 978-3-8327-9140-7

© 2006 teNeues Verlag GmbH + Co. KG, Kempen

Printed in Italy

Bibliographic information published by Die Deutsche Bibliothek.
Die Deutsche Bibliothek lists this publication in the Deutsche Nationalbibliografie;
detailed bibliographic data is available in the Internet at http://dnb.ddb.de.

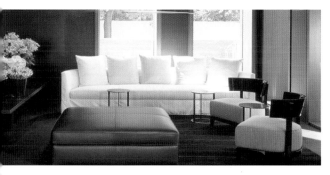
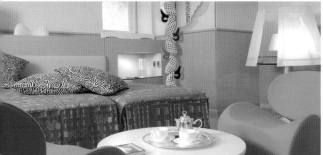

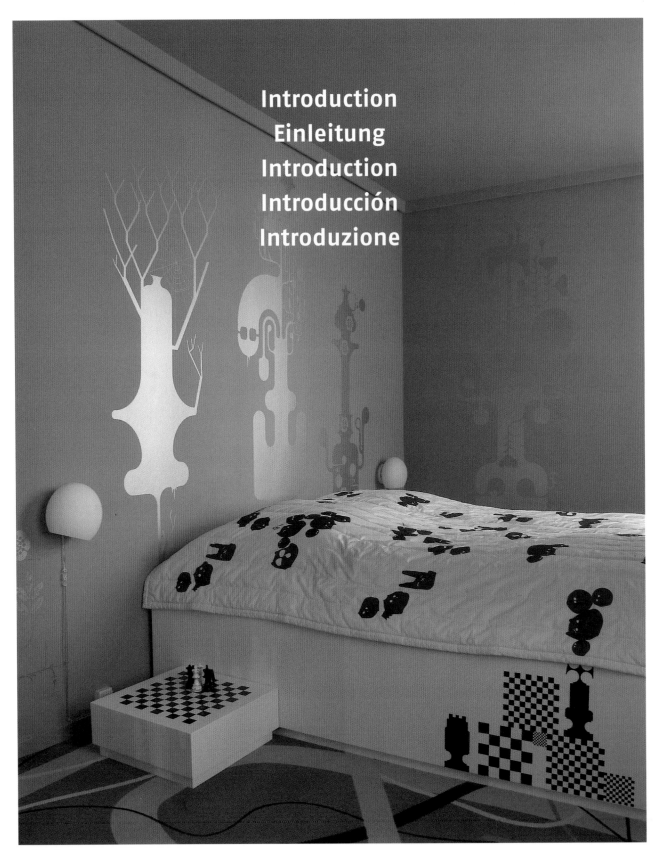

Introduction
Einleitung
Introduction
Introducción
Introduzione

Fashion and hotels are both inspirational and aspirational. Consumers have long been slavishly following fashion brands as they extend their reach way beyond garment creation. Wristwatches, sports ranges and home wares collections are all *derigueur* for couture houses. Now too *Fashion Hotels*. The display of Mulberry's home wares at Charlton House is an obvious step.

Fashion designers, Lacroix, Alaïa and De Cotiis, have applied their recognized talents to the "dressing" of hotel interiors. A chance for them to express, in a new media, the holistic philosophy and true lifestyle of a brand. And for shoppers, now guests, the chance for total immersion. To really "live" the brand.

The linking of global brands such as Bulgari and Ritz-Carlton provides both parties with mutual reassurance in their quest for greater exposure to new and reciprocally appreciative audiences. Other fashion companies have chosen a more singular approach with varying degrees of brand recognition. From Casa Camper and Byblos Art Hotel Villa Amistà to more subtle brand offerings. Such as the Gallery Hotel Art and Continentale from Salvatore Ferragamo or The Morrison by John Rocha. All exhibit the whimsical tastes and touches of their fashion counterparts.

Fashion Hotels showcases this architectural enhancement of the glamour of haute couture, as fashion designers seek new horizons for their multifarious products.

Die Mode- und die Hotelwelt sind sowohl inspirierend als auch ambitioniert. Konsumenten folgen schon lange sklavisch den Modemarken, da ihr Einflussbereich weit über die Bekleidungsindustrie hinausreicht. Kollektionen für Armbanduhren, Sportausstattungen und Wohnaccessoires sind für die Modehäuser bereits ein Muss geworden. Jetzt eben auch *Fashion Hotels*. Dass Wohnaccessoires von Mulberry im Charlton House gezeigt werden, ist ein offensichtlicher Schritt in diese Richtung.

Modeschöpfer, etwa Lacroix, Alaïa und De Cotiis, haben ihr anerkanntes Talent zum „Einkleiden" der Innenausstattung von Hotels eingesetzt. Eine Chance für sie, die ganzheitliche Philosophie und den wahren Lebensstil einer Marke in einem neuen Medium auszudrücken. Und für die Käufer, jetzt Gäste, die Chance zum vollständigen Eintauchen. Um die Marke wirklich zu „leben".

Die Verbindung globaler Marken wie etwa Bulgari und Ritz-Carlton bietet beiden Seiten gegenseitige Bestätigung in ihrer Suche nach Möglichkeiten, sich einem neuen Publikum zu präsentieren, das dies dann auch zu würdigen weiß. Andere Modefirmen haben einen einzigartigen Ansatz gewählt, wobei der Grad der Markenerkennung variiert. Von Casa Camper und dem Byblos Art Hotel Villa Amistà bis zu subtileren Markenangeboten. So wie etwa das Gallery Hotel Art und das Continentale von Salvatore Ferragamo oder The Morrison von John Rocha. Alle stellen die wundersamen Geschmäcker und Stile der Gegenstücke ihrer Mode aus.

Fashion Hotels zeigt diese architektonische Erweiterung des Glamours der Haute Couture, bei der Modeschöpfer neue Horizonte für ihre mannigfaltigen Produkte suchen.

Le monde de la mode et des hôtels inspire tout en étant ambitieux. Les consommateurs ont pendant longtemps suivi servilement les marques de mode quand elles étendaient leur influence en dehors du domaine de la mode. Les montres, les gammes de sport et les collections d'objets pour la maison sont toutes *de rigueur* pour les maisons de haute couture. Maintenant, les hôtels de mode sont venus s'ajouter à la gamme. L'exposition des objets de maison de Mulberry à Charlton House est un début évident.

Les créateurs de mode Lacroix, Alaïa et De Cotiis ont utilisé leurs talents reconnus pour « habiller » l'intérieur des hôtels. Il s'agit pour eux d'une opportunité pour exprimer, dans un nouveau média, la philosophie globale et le réel style de vie d'une marque. Pour les acheteurs, ici les hôtes, cela constitue une occasion pour s'immerger totalement. De vraiment « vivre » une marque.

Le lien entre des marques mondiales telles que Bulgari et Ritz-Carlton fournit aux deux parties une assurance mutuelle dans leur quête d'une meilleure présentation à des publics nouveaux et réciproquement attentifs. D'autres maisons de mode ont choisi une approche plus individuelle avec des degrés de reconnaissance de marque variables. De Casa Camper et Byblos Art Hotel Villa Amistà à des offres de marques plus subtiles. Telles que le Gallery Hotel Art et Continentale de Salvatore Ferragamo ou The Morrison par John Rocha. Tous affichent les goûts et détails curieux de leurs homologues de la mode.

Fashion Hotels illustre cette valorisation architecturale de l'éclat de la haute couture, lorsque les créateurs de mode recherchent de nouveaux horizons pour leurs produits multiples.

Los mundos de la moda y de los hoteles son inspiradores así como ambiciosos. Desde hace ya mucho tiempo, los consumidores son fieles seguidores de las marcas de moda, cuya influencia se ha extendido más allá de la industria textil. Las colecciones de relojes de pulsera, la indumentaria deportiva y los artículos para el hogar se han hecho ya imprescindibles para las casas de moda. Ahora llegan también los hoteles de moda. Es un avance evidente que la Charlton House muestra los artículos para el hogar de Mulberry.

Creadores como Lacroix, Alaïa y De Cotiis han puesto su reconocido talento al servicio del diseño de interiores en hoteles. Esto les brinda la oportunidad de expresar, en un nuevo espacio, la totalidad de la filosofía y el estilo de vida real de una marca, mientras que a los consumidores, en este caso huéspedes, se les da la oportunidad de sumergirse y vivir la marca totalmente.

La unión de marcas universales como, por ejemplo, Bulgari y Ritz-Carlton, ratifica a ambas partes en su búsqueda de oportunidades para presentarse a un público nuevo, que más tarde sabrá apreciar. Otras marcas de moda han elegido un punto de partida más propio, en el que varía el grado de reconocimiento de la marca y que va desde la Casa Camper y el Byblos Art Hotel Villa Amistà hasta ofertas de marcas más sutiles, como el Gallery Hotel Art y el Continentale de Salvatore Ferragamo o The Morrison de John Rocha. Todos representan el gusto y el estilo curiosos de sus creacciones de moda.

Fashion Hotels le muestra esa ampliación arquitectónica del glamour de la alta costura, en la que los diseñadores de moda buscan nuevos horizontes para sus diversos productos.

La moda e gli hotel evidenziano entrambi ispirazioni e aspirazioni. I consumatori hanno seguito schiavizzati le marche di moda poiché esse estendono il loro raggio ben oltre la creazione di tessuti. Orologi da polso, collezioni sportive e collezioni di accessori per la casa sono tutti dei *derigueur* per le Case di moda. Ora anche *Fashion Hotels*. L'esposizione di accessori per la casa di Mulberry a Charlton House è un passo ovvio.

I designer di moda, Lacroix, Alaïa e De Cotiis, hanno applicato il loro talento riconosciuto al "vestire" degli ambienti interni degli hotel. Una possibilità per loro di esprimere, in un nuovo mezzo, la filosofia pluridisciplinare e il vero stile di vita di una marca. E per gli acquirenti, ora ospiti, la possibilità di un'immersione totale. Per "vivere" veramente la marca.

La connessione di marche globali quali Bulgari ed il Ritz-Carlton dà a entrambe le parti una rispettiva riassicurazione nella loro lotta per una maggiore esposizione ad un'audience nuova e con apprezzamento reciproco. Altre aziende di moda hanno scelto un approccio più singolare per livelli diversi di recognizione della marca. Da Casa Camper e Byblos Art Hotel Villa Amistà fino ad offerte più sottili di marca. Come ad es. il Gallery Hotel Art ed il Continentale di Salvatore Ferragamo oppure The Morrison di John Rocha. Tutti esibiscono i gusti incredibili e i tocchi delle loro corrispondenze di moda.

Fashion Hotels mostra questo sviluppo a livello di architettura del glamour dell'alta moda, come i designer di moda cercano nuovi orizzonti per i loro molteplici prodotti.

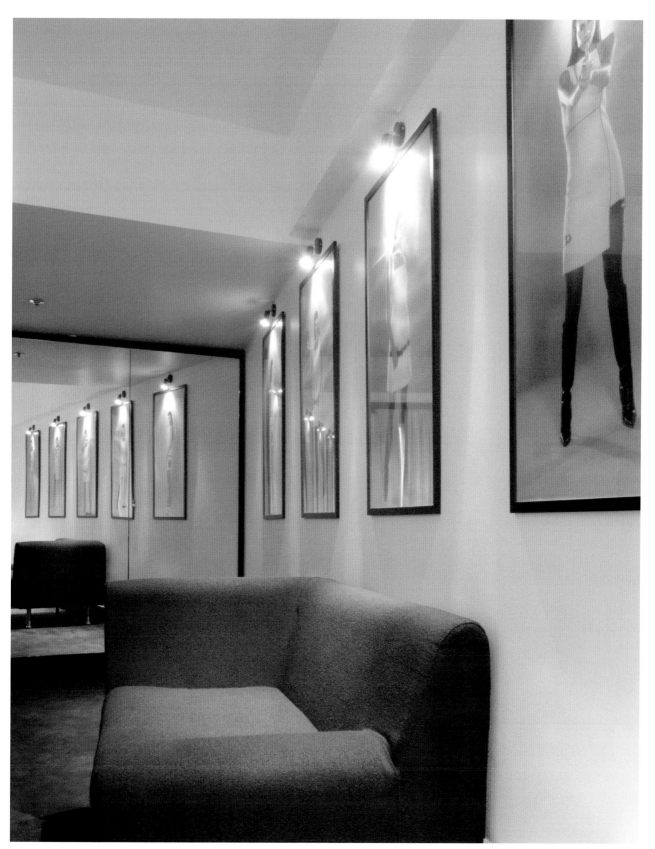

3 rooms – 10 Corso Como

Corso Como 10 • 20154 Milan • Italy • www.3rooms-10corsocomo.com

2003
Carla Sozzani • www.galleriacarlasozzani.com
Kris Ruhs • www.krisruhs.com
Photos: Douglas Kirkland, courtesy 10 Corso Como

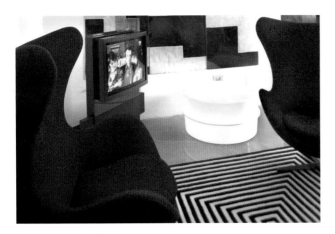 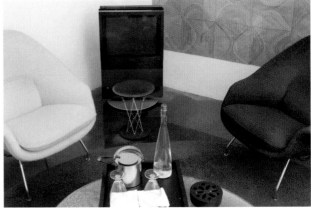

The eclectic cult fashion complex at 10 Corso Como by Carla Sozzani now extends to three suites. Here bold patterns, artwork and mosaic combine to create unique personal spaces. Furnishings are of a mid 20th Century vibe from Eames to Gio Ponti.

Der eklektische Kult-Modekomplex des 10 Corso Como von Carla Sozzani umfasst jetzt drei Suiten. Hier mischen sich kühne Muster, Kunstwerke und Mosaiken zu einzigartigen persönlichen Räumen. Die Einrichtung stammt aus der Mitte des 20. Jahrhunderts, von Designern wie Eames und Gio Ponti.

Ce complexe de mode de culte éclectique au 10 Corso Como créé par Carla Sozzani s'étend maintenant à trois suites. Des formes osées, des œuvres d'art et des mosaïques sont combinées ici pour créer des espaces personnels uniques. Le mobilier de Eames à Gio Ponti est du style du milieu du 20ème siècle.

Este complejo de moda ecléctico de Carla Sozzani, en el 10 Corso Como, posee ahora tres suites. En ellas se mezclan muestras atrevidas, diseños artísticos y mosaicos en unos espacios únicos y peculiares. La decoración tiene su origen en el ambiente de mediados del siglo XX y abarca desde Eames a Gio Ponti.

Il complesso eclettico del culto della moda a 10 Corso Como di Carla Sozzani ora si amplia di tre suite. Qui modelli spavaldi, opere d'arte ed il mosaico si combinano per creare degli spazi personali unici. Gli arredamenti sono nello stile della metà del XX secolo create da Eames a Gio Ponti.

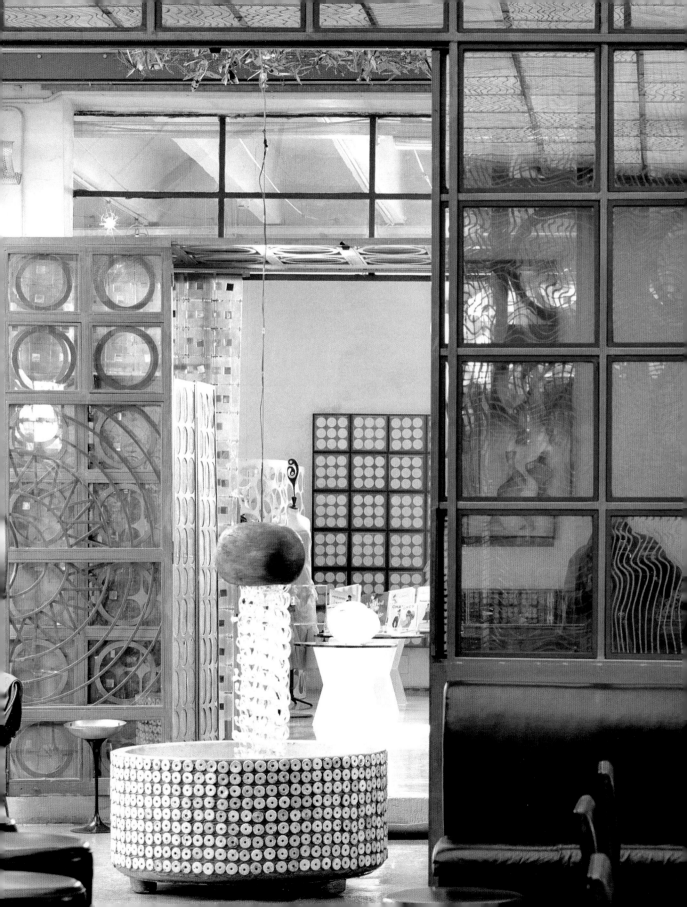

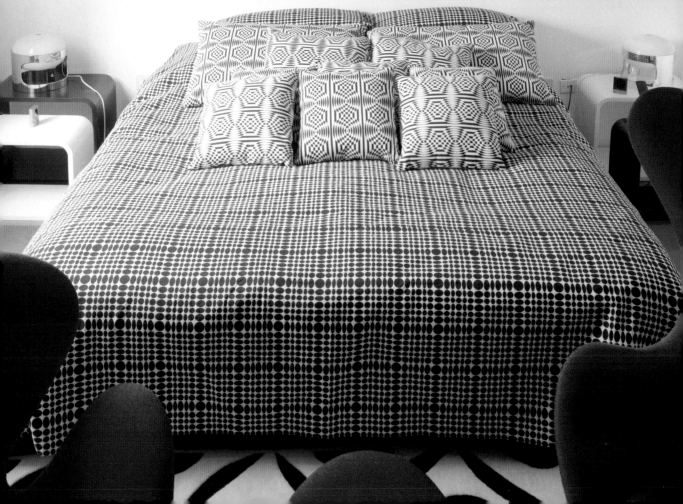

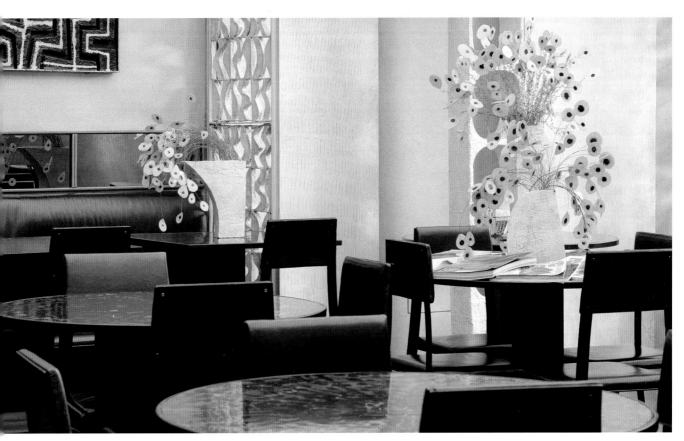

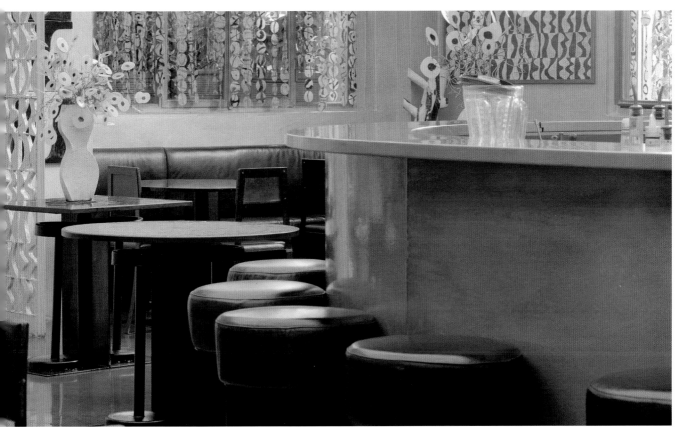

5 Rue De Moussy

5, Rue de Moussy • 75004 Paris • France

2004

Azzedine Alaïa

Photos: Christoph Kicherer

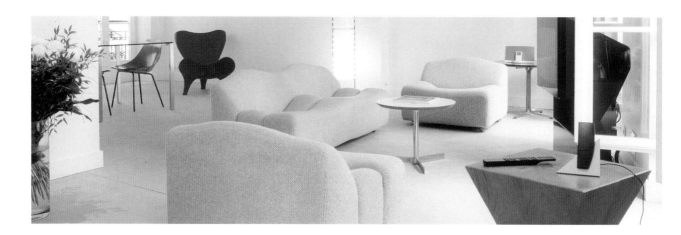

The relatively stark whiteness of the three apartments attached to Alaïa's boutique and atelier in the Marais is softened by his personal and meticulous attention to the evolving arrangements. Modernist metal furniture by Jean Prouvé sits besides covetable designs from friend, Marc Newson.

Das blendende Weiß der drei Appartements, die zu Alaïas Boutique und Atelier im Marais-Viertel gehören, wird dadurch abgeschwächt, dass sich der Designer selbst auf sehr persönliche und sorgfältige Art und Weise in die entstehenden Arrangements einbringt. Modernistische Möbel aus Metall von Jean Prouvé stehen neben begehrten Designs seines Freundes Marc Newson.

Là blancheur relativement sévère des trois appartements attachés à la boutique et à l'atelier Alaïa dans le Marais est atténuée par l'attention personnelle et méticuleuse apportée aux arrangements élaborés. Des meubles modernistes en métal par Jean Prouvé côtoient des designs convoitables de son ami Marc Newson.

La blancura relativamente intensa de estos tres apartamentos, que pertenecen a la boutique y al atelier de Alaïa, en el Marais, se suaviza gracias a su consideración precisa y peculiar de las estructuras. Los muebles de metal modernistas de Jean Prouvé se encuentran junto a los apreciados diseños de su amigo Marc Newson.

Il bianco relativamente brillante dei tre appartamenti attaccati alla boutique ed atelier di Alaïa nel Marais viene addolcito dalla sua attenzione personale e meticolosa ad un'ordine in evoluzione. Arredamenti in metallo nello stile modernista di Jean Prouvé sono posizionati vicino al design molto ambito dell'amico, Marc Newson.

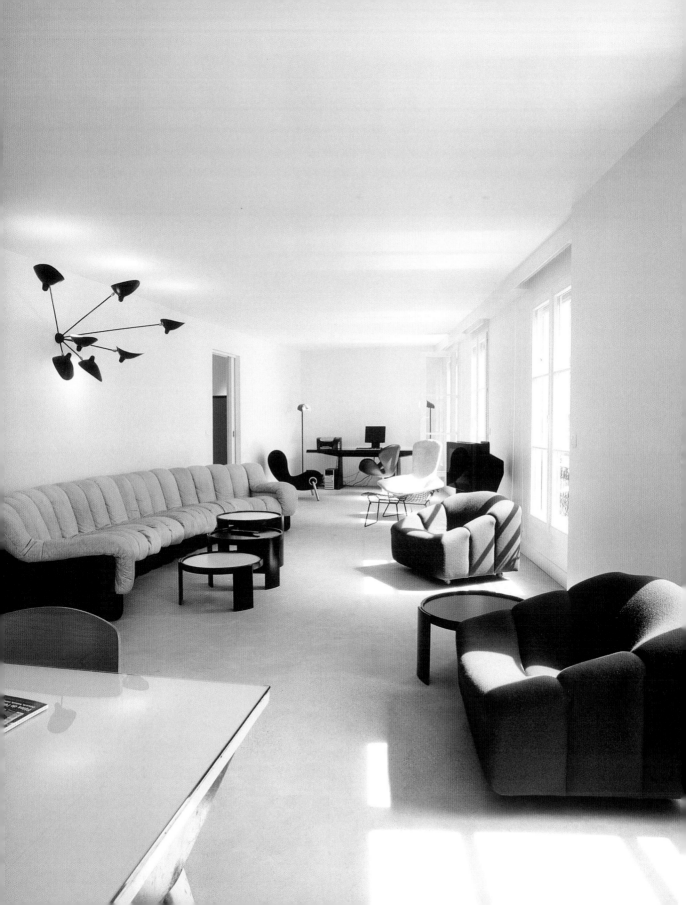

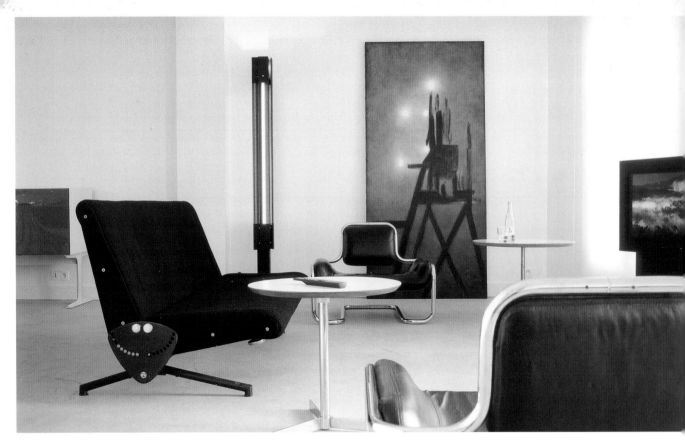

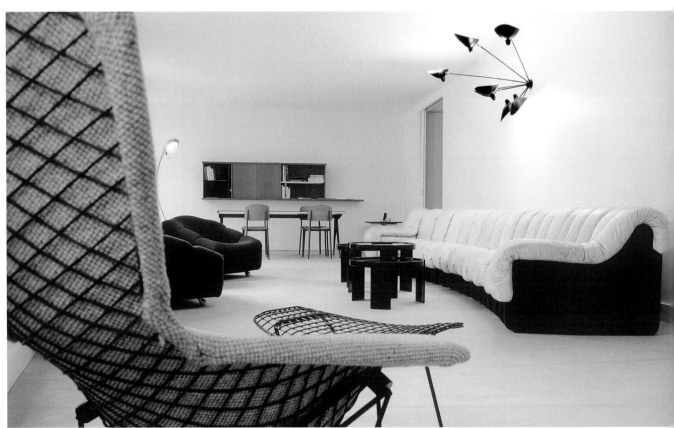

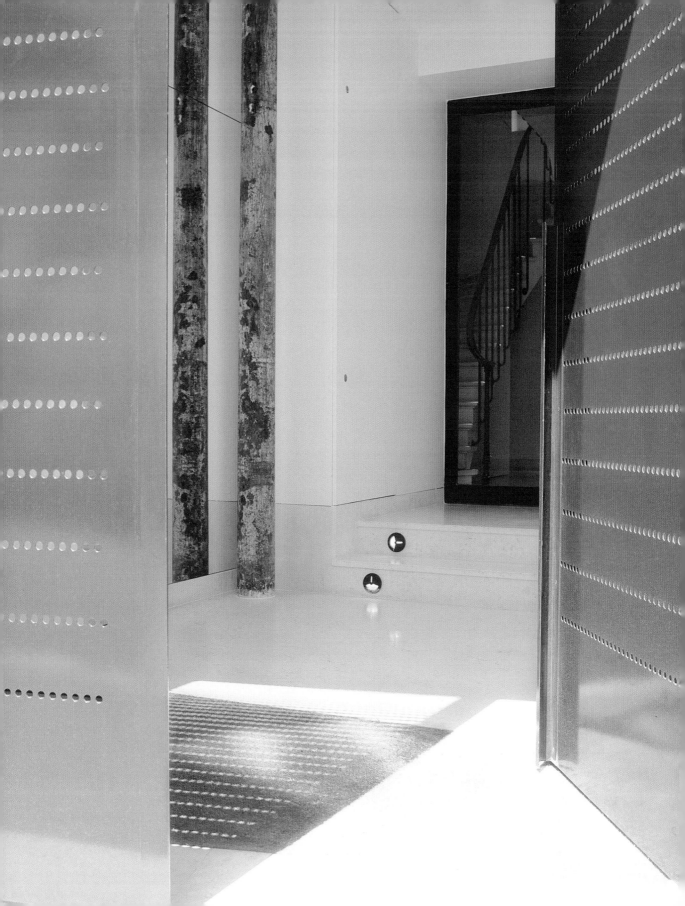

Biba Hotel

320 Belvedere Road • West Palm Beach, Florida 33405 • USA • www.hotelbiba.com

2001
Barbara Hulanicki
Photos: Alissa Dragun, Cookie Kinkead, courtesy Biba Hotel

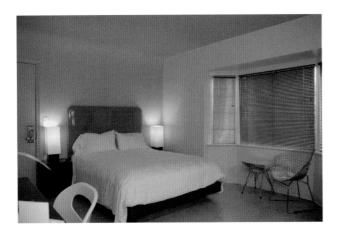

The serene, palm tree fronted motor lodge porch of this West Palm Beach hotel belies the melange of colors in the hippy chic interiors. The silver vinyl upholstery and beaded curtains are a throwback to designer Hulanicki's 60's heyday.

Die ruhige, palmengesäumte Veranda dieses Hotels in West Palm Beach täuscht über die Farbmischung der Interieurs im Hippie-Chic hinweg. Die silbernen Vinylpolster und die mit Perlen verzierten Gardinen sind ein Rückgriff auf den Höhepunkt des Schaffens der Designerin Hulanicki in den 60ern.

Le porche serein bordé de palmiers de cet hôtel de West Palm Beach dissimule le mélange de couleurs dans les intérieurs d'un chic hippie. Les capitonnages en vinyle argent et les rideaux perlés sont un renvoi aux jours de gloire de la créatrice Hulanicki dans les années 1960.

El tranquilo mirador rodeado de palmeras de este hotel en West Palm Beach contrasta con la mezcla de colores de sus espacios interiores del estilo hippy. Los colchones de vinilo plateado y las cortinas decoradas con perlas se remontan al punto álgido de la creación de la diseñadora Hulanicki, en los años sesenta.

La loggia serena ed il frontone con alberi di palma di questo hotel di West Palm Beach non corrispondono per niente al mélange di colori degli interni hippy, le tappezzerie in vinile argentato e le tende decorate con perle ricordano al periodo di splendore degli Anni 60 della designer Hulanicki.

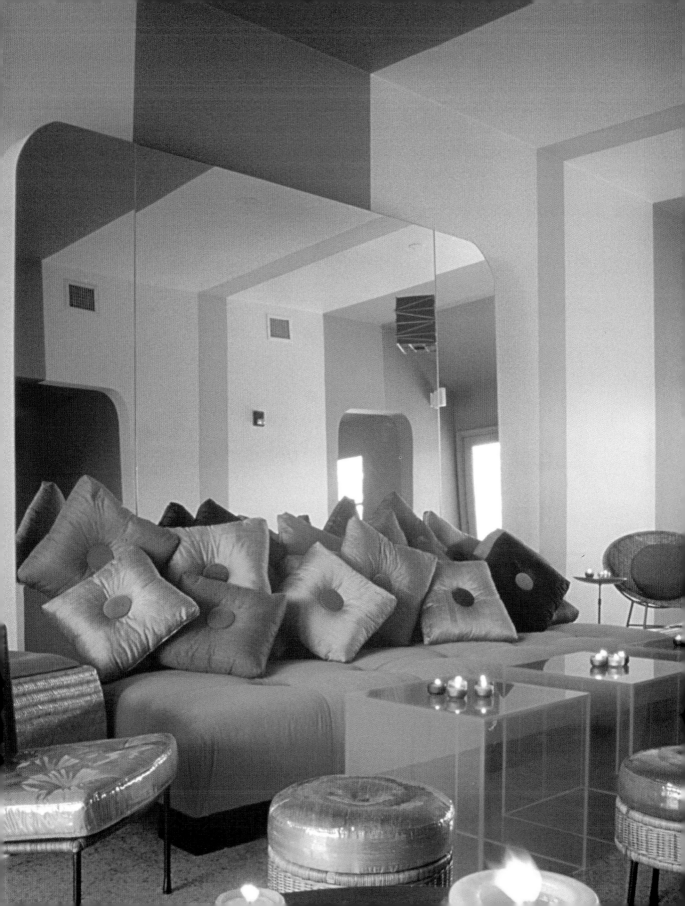

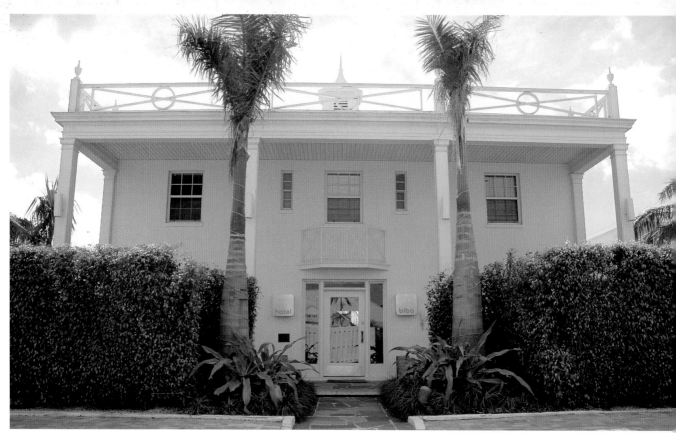

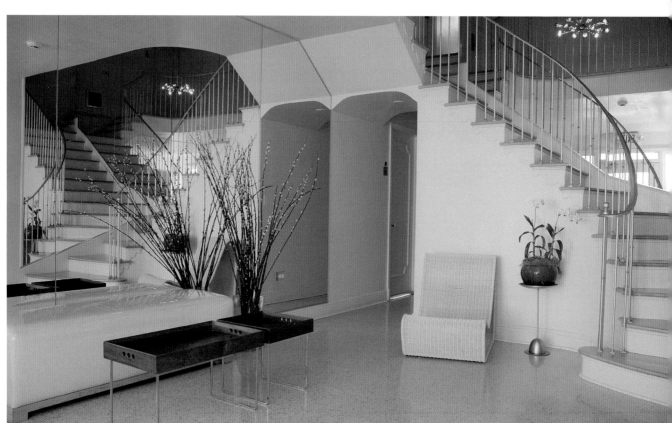

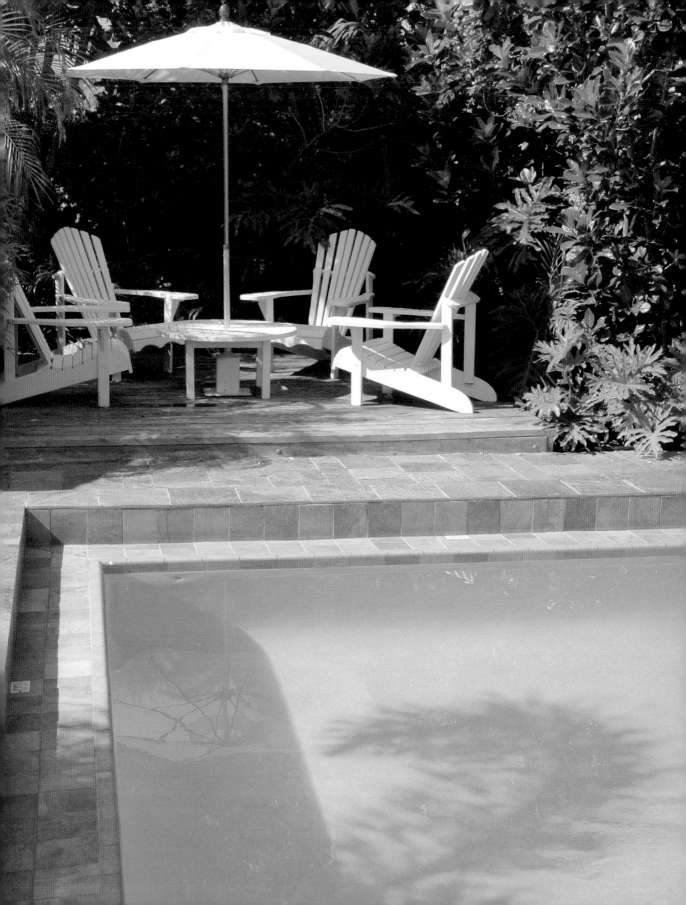

Blakes

33 Roland Gardens • London, SW7 3PF • UK • www.blakeshotels.com

2005
Anouska Hempel Design
www.anouskahempeldesign.com
Photos: Gavin Jackson

 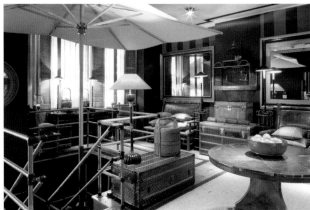

For many, the first true boutique hotel, Blakes, continues to effortlessly blend Hempel's idiosyncratic touches. Biedermeier meets Baroque. Flighty and flirty contrasts with Asian accord. Chinoiserie abuts imperial order. Altogether an intoxicating allure.

Für viele ist das Blakes, das erste wirkliche Boutiquehotel, nach wie vor eine mühelose Verbindung von Hempels speziellen Eigenarten. Biedermeier trifft Barock. Flatterhaftigkeit und Koketterie treten in Kontrast mit asiatischem Einklang. Chinoiserie stößt auf kaiserliche Ordnung. Insgesamt ein berauschender Reiz.

Pour beaucoup, le premier vrai hôtel de boutique Blakes continue à marier sans effort apparent les touches idiosyncrasiques de Hempel. Le Biedermeier rencontre le Baroque. Des contrastes volages et coquets avec des accords asiatiques. Les chinoiseries se butent à l'ordre impérial. Somme toute une allure intoxicante.

Para muchos, el primer hotel boutique de Blake sigue siendo una mezcla de los matices idiosincráticos de Hempel. El Biedermeier se encuentra con el Barroco. La volubilidad y la coquetería contrastan con los toques asiáticos. Los rasgos de estilo chino se cruzan con los del orden imperial. Un encanto embriagador en su conjunto.

Per molti, il vero primo boutique-hotel, il Blakes continua a mescolare i tocchi bizzarri di Hempel. Il Biedermeier incontra il Barocco. Contrasti farfalloni e da flirt assieme ad accordi asiatici. Merci cinesi abbattono l'ordine imperiale. In tutto un'allure intossicante.

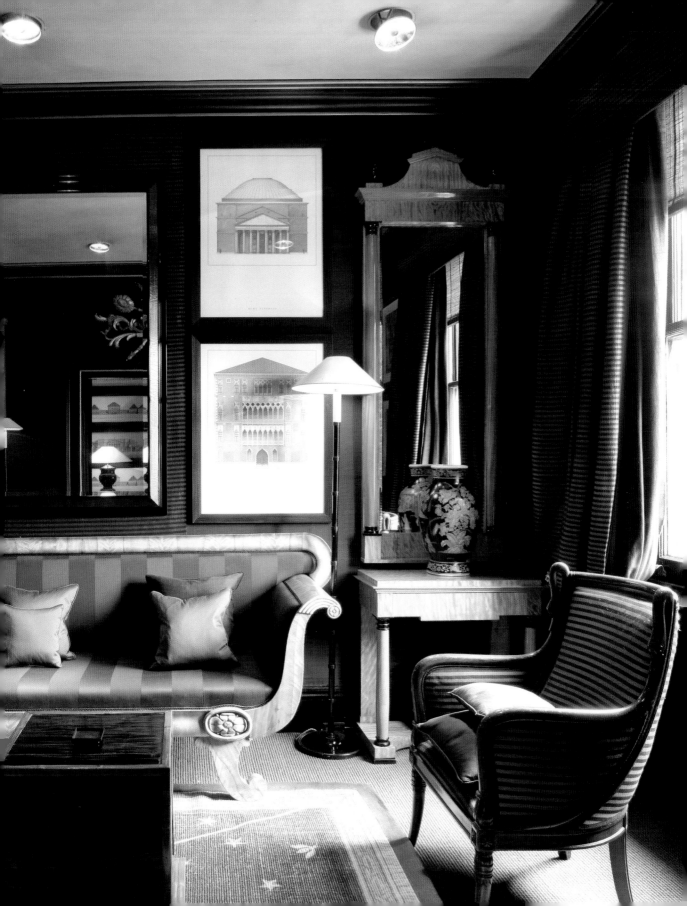

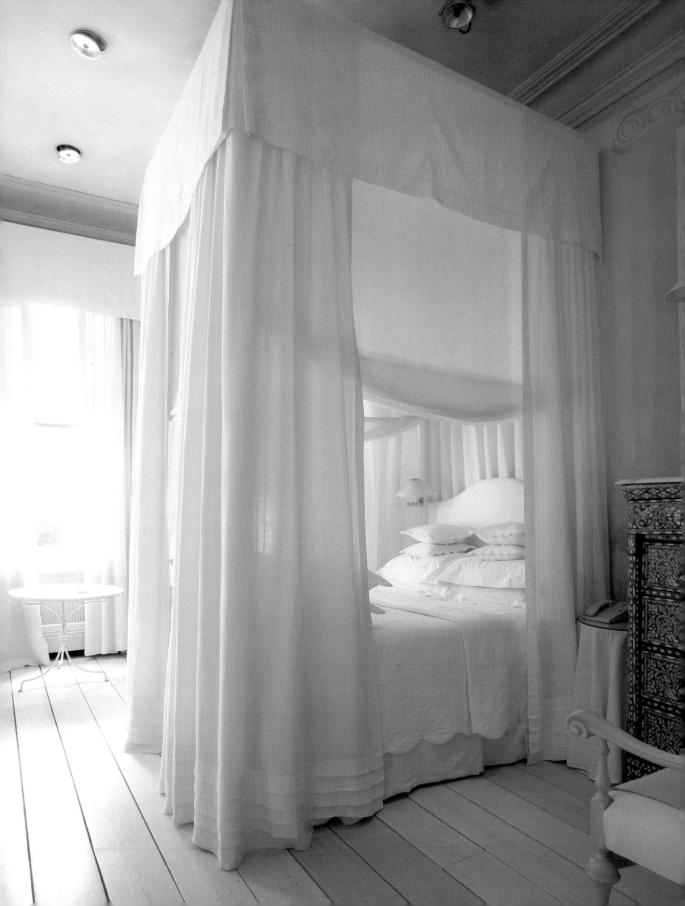

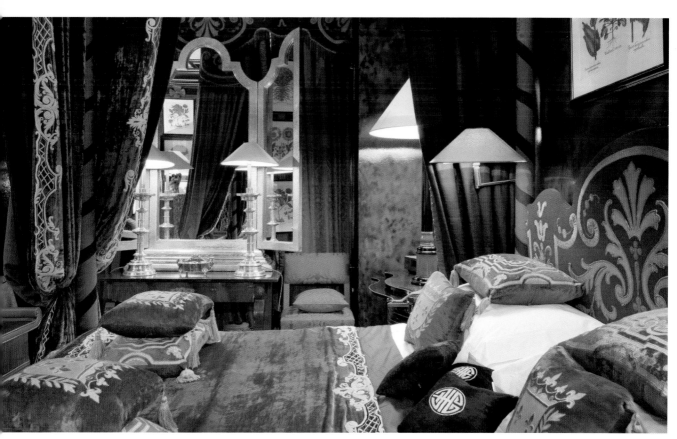

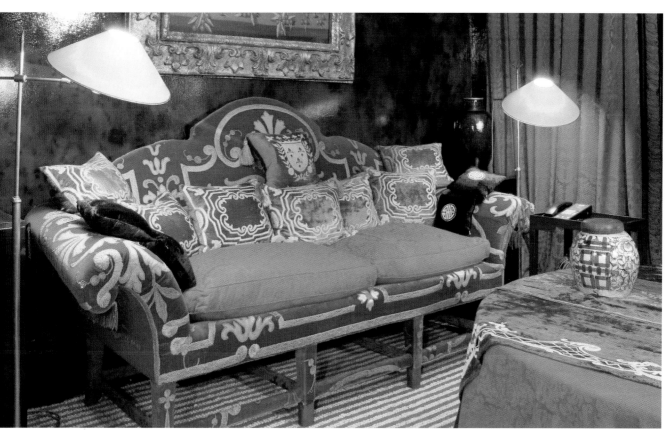

Bulgari Hotel

Via Privata Fratelli Gabba 7/b • 20121 Milan • Italy • www.bulgarihotels.com

2004
Antonio Citterio & Partners
www.antonio-citterio.it
Photos: Bulgari

Citterio, a master of fashion flagship store design, takes his display skills to new levels in this converted Milanese monastery. The calm, assured physical presence of this jewel box of a hotel allows focus on the interior design details and luxurious finishes.

Citterio, ein Meister des Flagshipstore-Designs für Modeshops, bringt seine Fähigkeiten, Dinge in Szene zu setzen, in diesem umgebauten Mailänder Kloster auf eine neue Ebene. Durch die ruhige, sichere physische Präsenz dieses Schmuckkästchens von Hotel ist es möglich, sich auf die Details der Innenausstattung und die luxuriösen Oberflächen zu konzentrieren.

Citterio, un maître du design des boutiques de mode modèles, pousse son savoir-faire d'exposition à un nouveau niveau dans ce monastère milanais aménagé. La présence physique calme et assurée de ce joyau d'hôtel permet de se concentrer sur les détails du design intérieur et des finitions luxueuses.

Citterio, un maestro del diseño de tiendas que son el buque insignia, lleva su habilidad como expositor a un nuevo nivel en este monasterio reformado de Milán. Gracias a la apariencia tranquila y segura de esta alhaja de hotel, es posible concentrarse en los detalles de la decoración de los espacios interiores y de las superficies lujosas.

Citterio, un maestro del design dei Flagship store di moda, eleva portando a nuovi livelli le sue capacità di evidenziare la qualità in questo monastero Milanese. La calma e la tranquilla presenza fisica di questo gioiello di hotel permettono di concentrarsi sui dettagli del design degli interni e delle lussuose finiture.

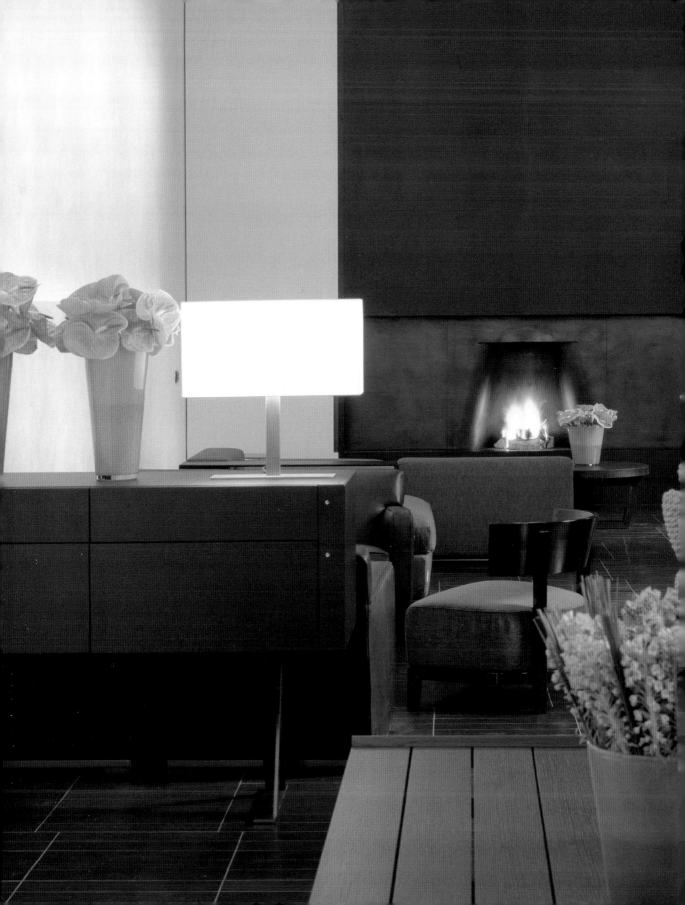

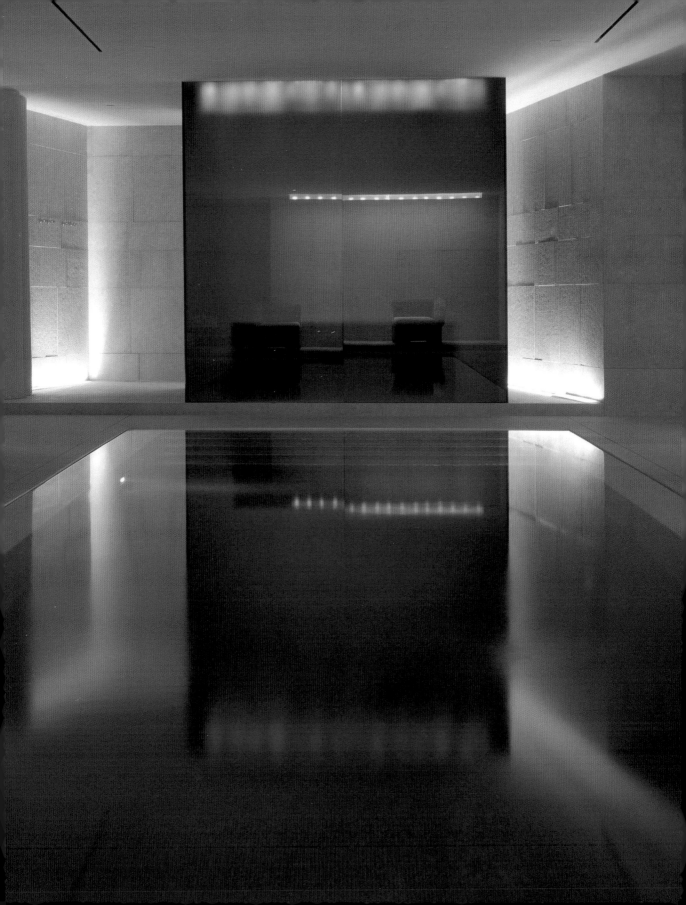

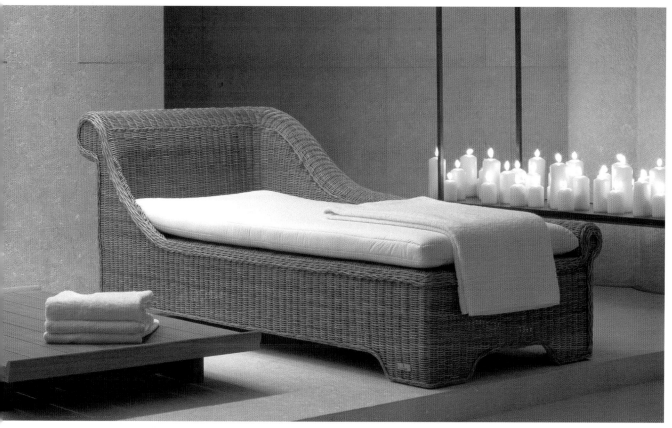

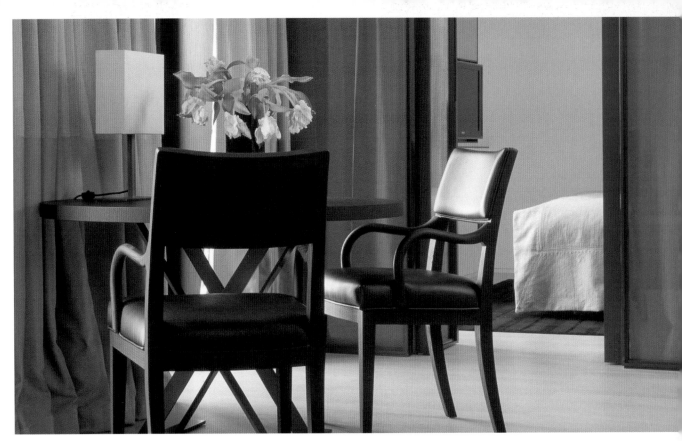

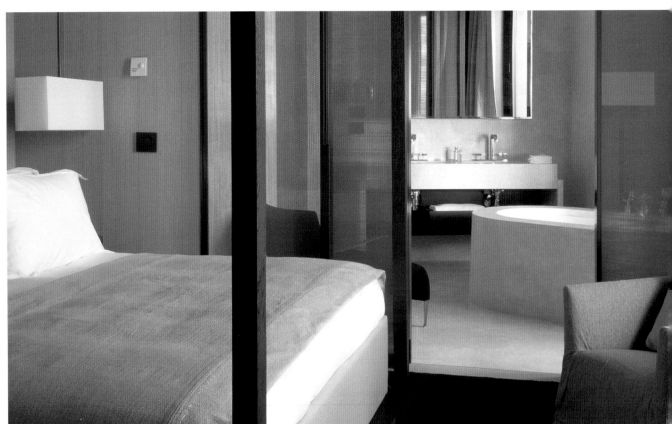

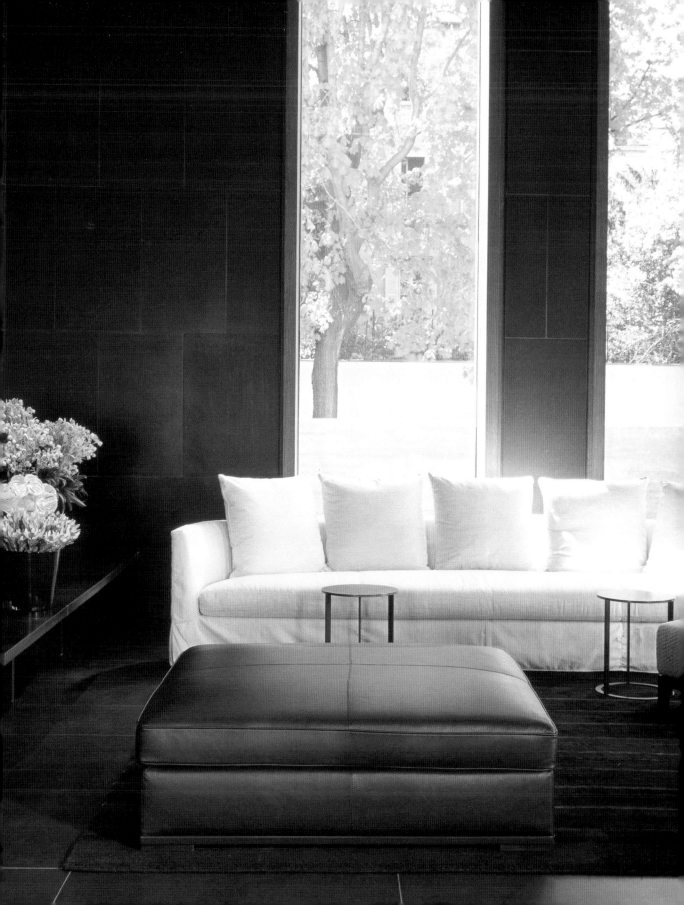

Byblos Art Hotel Villa Amistà

Via Cedrare, 78 • 37029 Corrubbio di Negarine, Verona • Italy • www.byblosarthotel.com

2005
Atelier Mendini
www.ateliermendini.it
Photos: Henri del Olmo

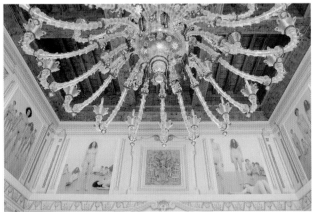

This former aristocratic residence, with its 16th century façade, houses an outstanding assembly of contemporary furniture and art which are part of the collection of Dino Facchini. The colorful neo-baroque interiors of Italian architect Alessandro Mendini make this a living museum.

Diese ehemalige Adelsresidenz mit ihrer Fassade aus dem 16. Jahrhundert beherbergt eine hervorragende Sammlung zeitgenössischer Möbel und Kunstwerke, die Teil der Kollektion Dino Facchinis sind. Der bunte neobarocke Innenbereich des italienischen Architekten Alessandro Mendini macht das Hotel zu einem lebendigen Museum.

Cet ancien hôtel particulier avec sa façade du 16ème siècle héberge un ensemble remarquable de mobilier et d'art contemporains qui font partie de la collection de Dino Facchini. Les intérieurs colorés d'un style néo-baroque de l'architecte italien Alessandro Mendini en font un musée vivant.

Esta antigua residencia de la nobleza con su fachada del siglo XVI aloja una colección excelente de muebles y obras de arte contemporáneos, que forman parte de la colección de Dino Facchini. El colorido interior de estilo neobarroco del arquitecto italiano Alessandro Mendini lo convierten en un museo vivaz.

Questa ex residenza dei nobili con la sua facciata del XVI secolo è un incredibile assemblaggio di arredamenti contemporanei ed artistici che sono parte della collezione di Dino Facchini. Gli interni neo-barocchi ricchi di colore, dell'architetto italiano Alessandro Mendini, rendono quest'hotel un museo vivente.

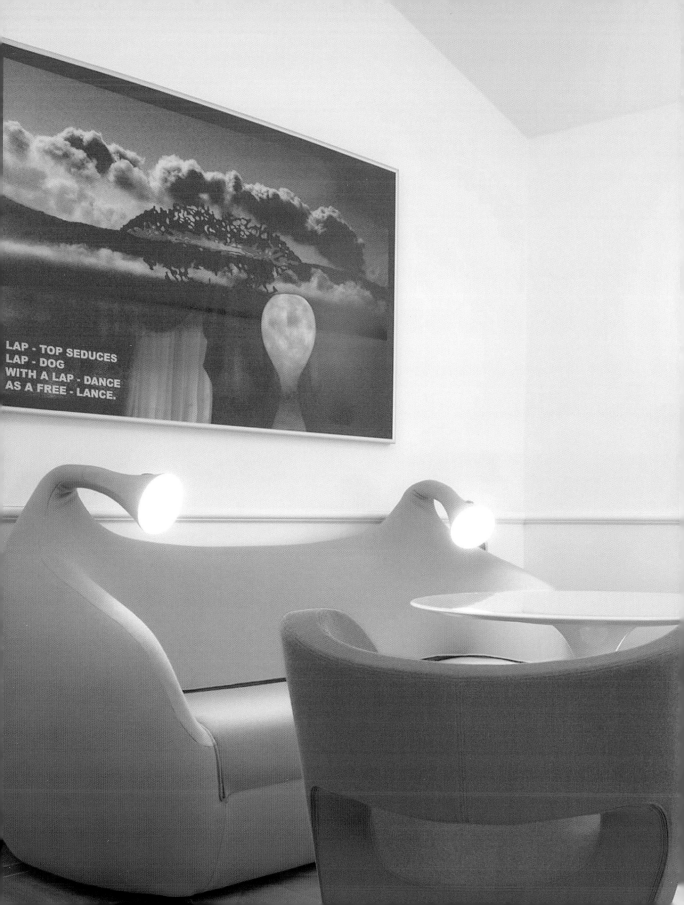

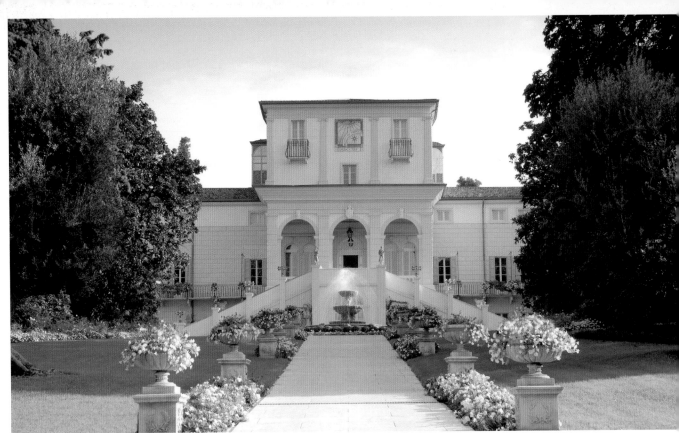

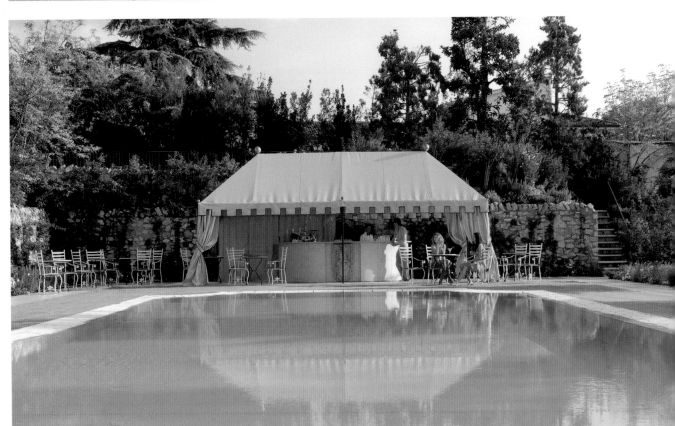

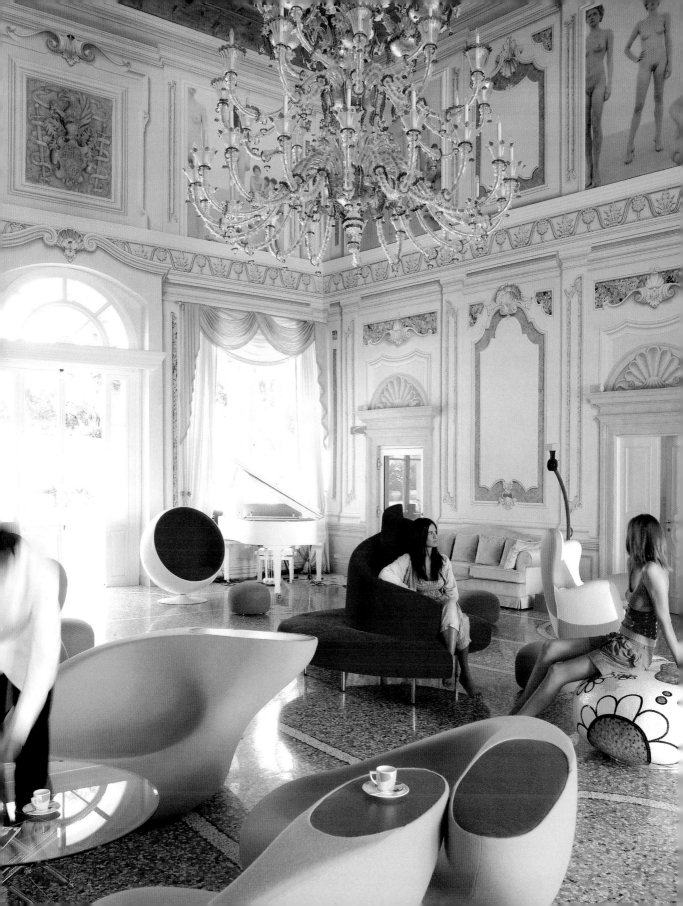

2004: 24 HOURS NIGHT (TELL ME, WHERE THE COLOURS HAVE GONE???)

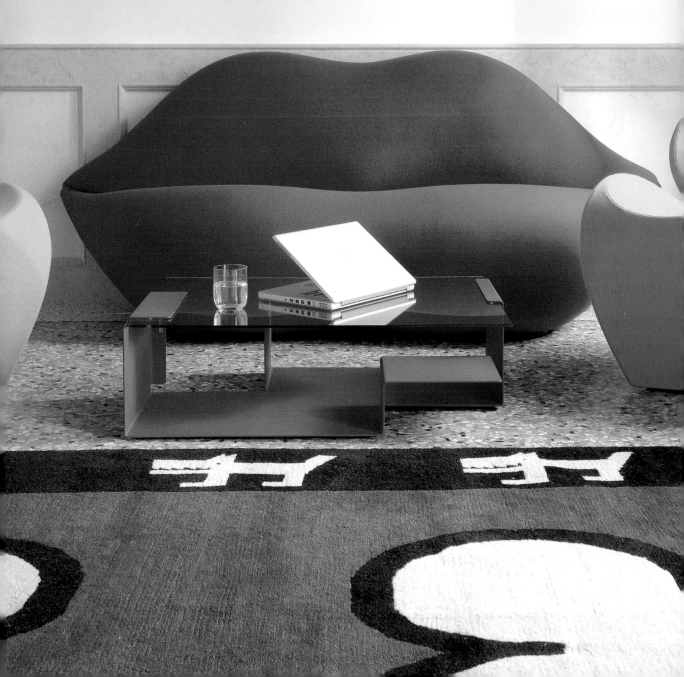

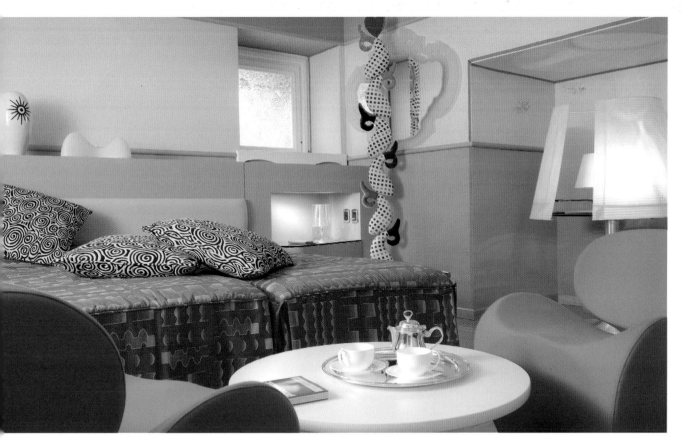

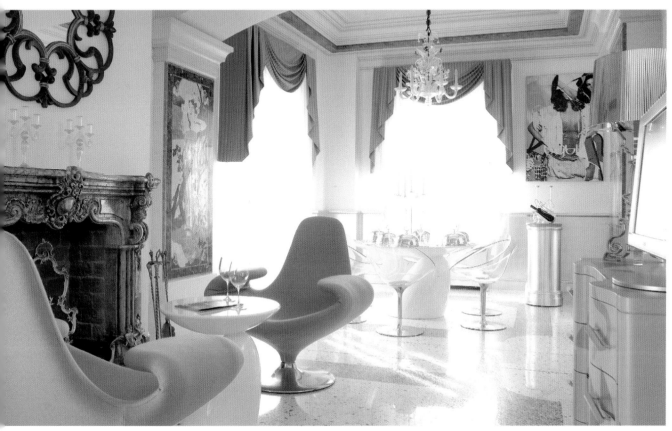

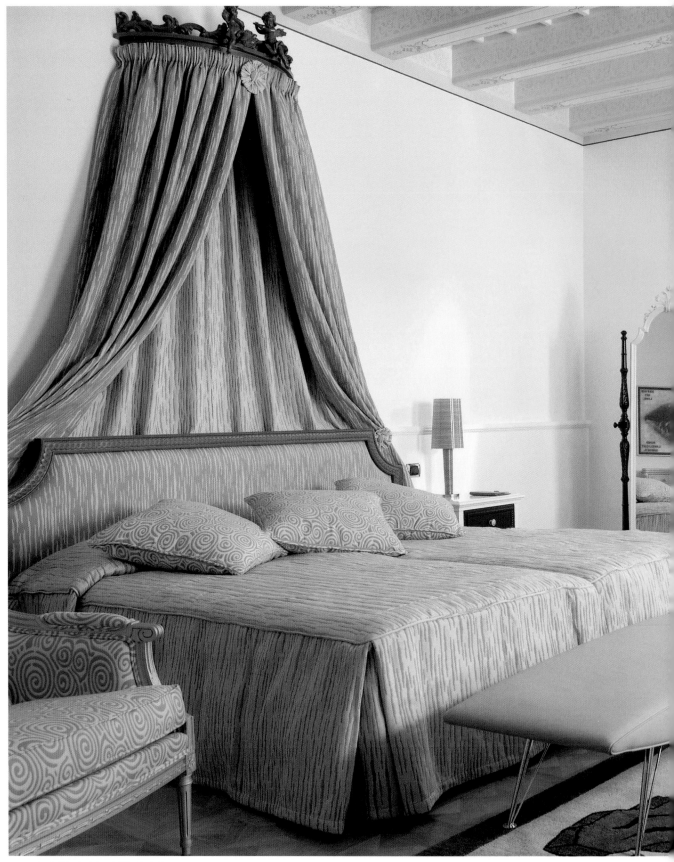

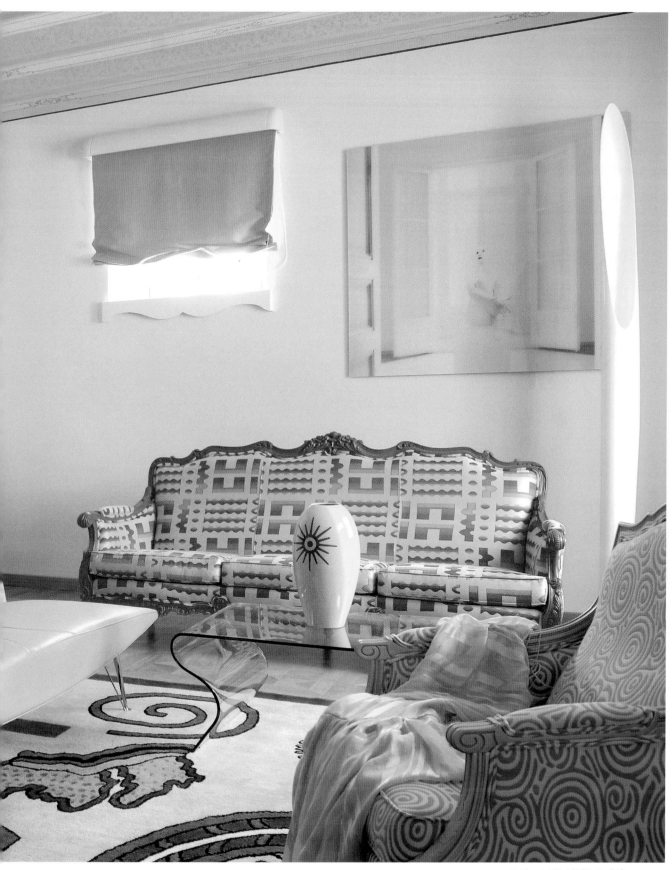

Carducci 76

Viale Carducci, 76 • 47841 Cattolica (RN) • Italy • www.carducci76.it

2000

Massimo Ferretti

Photos: Marchi & Marchi, Giuseppe Badioli, courtesy Carducci 76

The 1920's beachside villa in Ferretti's hometown has been fashioned in the designer's sophisticated Italian style. An ordered, geometric Eastern approach is merged with putty and stone color tones of an African colonial look including tribal prints.

Diese Strandvilla aus den 1920ern in Ferrettis Heimatstadt wurde im anspruchsvollen italienischen Stil des Designers gestaltet. Ein wohlgeordneter, geometrischer asiatischer Ansatz wird mit Grau-Braun-Tönen im afrikanischen Kolonialstil einschließlich Stammesmustern gemischt.

La villa côtière des années 1920 située dans la ville natale de Ferretti a été aménagée dans le style italien sophistiqué de ce créateur. Une approche Est asiatique ordonnée et géométrique se fond avec des tons gris bruns d'un look colonial africain, y compris les gravures tribales.

Esta villa de los años veinte, situada en la playa de la ciudad natal de Ferretti, se diseñó siguiendo el exigente estilo italiano de este diseñador. En su decoración se mezclan elementos geométricos ordenados del oriente con tonos de color marrón grisáceo al estilo colonial africano, que incluye pinturas tribales.

La villa degli Anni 20 lungo la spiaggia che si trova nella città natale di Ferretti è stata arredata in stile italiano sofisticato da designer. Un approccio ordinato e geometrico Orientale si mescola a toni di colore grigio-marrone di un look africano coloniale, con stampe tribali incluse.

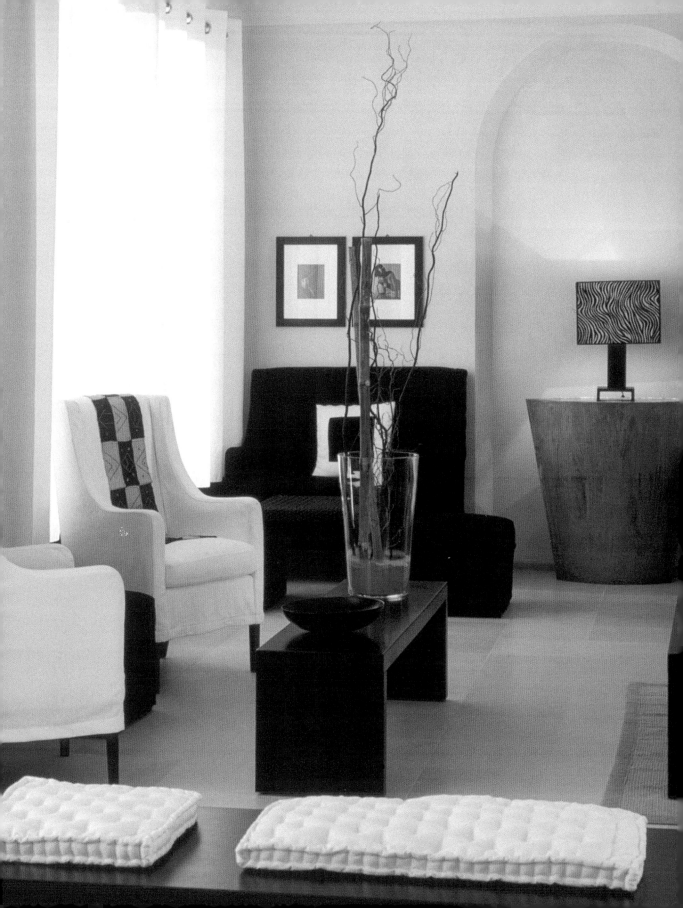

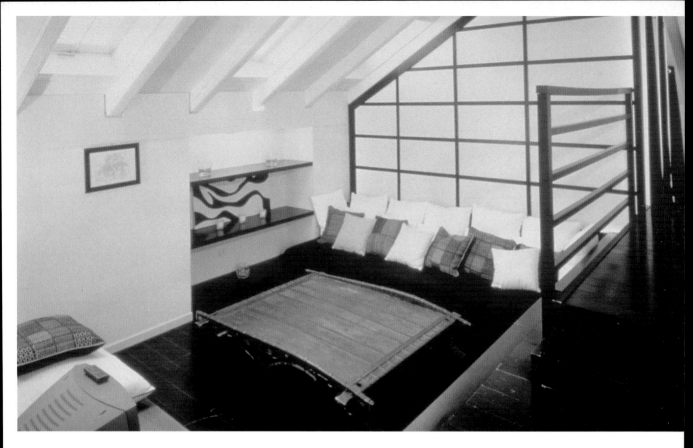

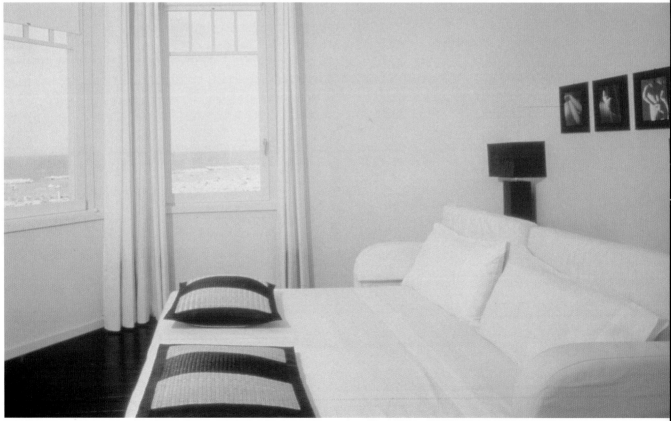

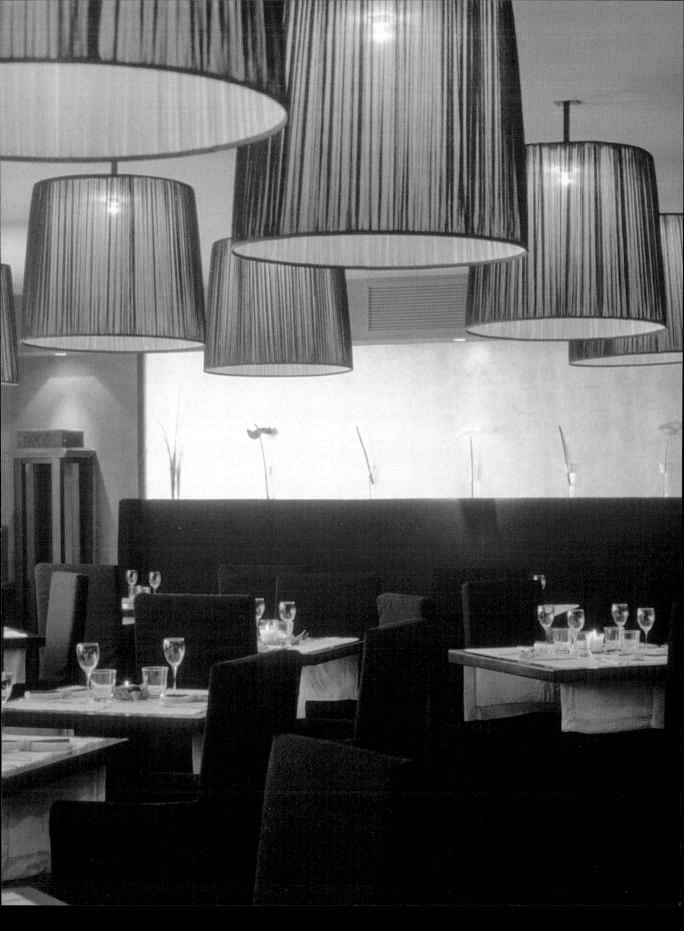

Casa Camper

Carrer Elisabets 11 • 08001 Barcelona • Spain • www.camper.com

2005

Architect: Jordi Tio

Interior Designer: Ferran Amat

www.vincon.com

Photos: Jordi Bernardo, courtesy Casa Camper

 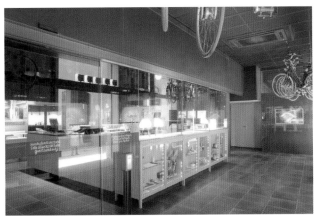

It is a bit off beat with bikes hanging from the lobby ceiling and each blood red guestroom having its own *Salita de Estar*, or living room with hammock, across the corridor. This is the unconventional Camper way from architect Ferran Amat.

Casa Camper ist ein bisschen ausgefallen mit den von der Decke der Lobby hängenden Fahrrädern und den blutrot gestrichenen Zimmern, die alle über eigene *Salita de Estar* oder ein Wohnzimmer mit Hängematte auf dem Flur verfügen. Das ist der unkonventionelle Stil von Camper, entworfen durch den Architekten Ferran Amat.

C'est un peu hors du commun avec des vélos qui pendent du plafond du lobby et des chambres rouge sang qui disposent chacune de leur propre *Salita de Estar*, ou séjour avec hamac de l'autre côté du couloir. C'est le style peu conventionnel de Camper de l'architecte Ferran Amat.

Las bicicletas que cuelgan del techo del lobby resultan curiosas. Las habitaciones, pintadas de rojo sangre, tienen su propia salita de estar o un salón con una hamaca de malla en el corredor. Todo diseñado al inconvencional estilo Camper del arquitecto Ferran Amat.

È un po' fuori dal comune con le biciclette appese sulle pareti della lobby ed ogni camera per gli ospiti di colore rosso sangue con la propria *Salita de Estar*, o salotto con amache, lungo il corridoio. Questo è l'inconvenzionale Camper secondo lo stile dell'architetto Ferran Amat.

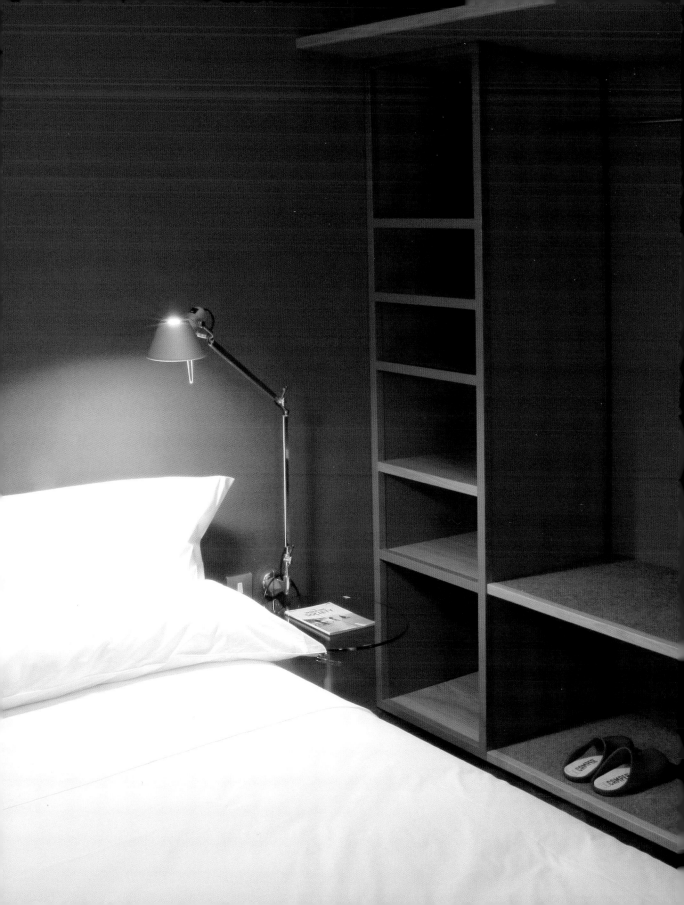

1
primera planta
first floor

Baja caminando,
es más sano.

Walk down,
it's healthier.

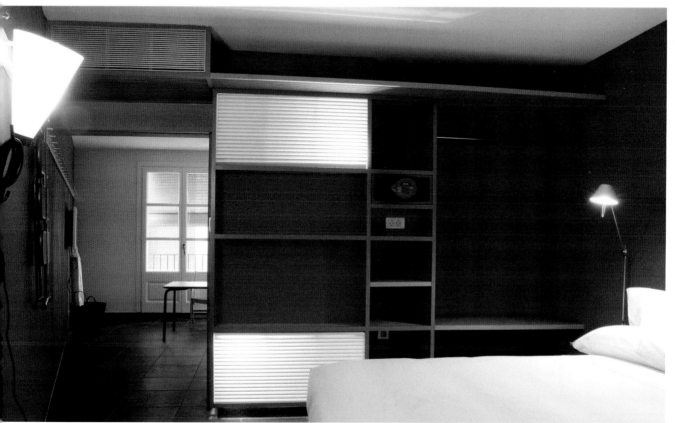

Charlton House

Shepton Mallet • Somerset BA4 4PR • UK • www.charltonhouse.com

1996
Chris Parker / Parker Associates
Photos: Nick Smith, Nicholas Gentilli, courtesy Charlton House

A country house homage to the home wares collection of Mulberry, Charlton House displays all the brand's elegant English eccentricities. Four poster beds, copper bathtubs and rooms with secret gardens are united by splendid velvets and hand worked leather goods.

Charlton House, eine Landhaushommage an die Kollektion der Wohnaccessoires von Mulberry, stellt alle eleganten englischen Verschrobenheiten der Marke aus. Himmelbetten, Kupferbadewannen und Zimmer mit versteckten Gärten werden durch herrliche Samtstoffe und handgearbeitete Lederwaren ergänzt.

Hommage d'une maison de campagne aux objets de maison de la collection Mulberry, Charlton House comprend toutes les excentricités élégantes anglaises de la collection. Des lits à baldaquin, des baignoires en cuivres, et des chambres avec des jardins secrets sont réunies par des velours splendides et des objets en cuir fait à la main.

La Charlton House es una casa de campo que rinde homenaje a la colección de artículos para el hogar de Mulberry, los cuales muestran toda la elegante extravagancia inglesa de la marca. A las camas con dosel, bañeras de cobre y habitaciones con jardines ocultos se le unen los terciopelos y los cueros elaborados artesanalmente.

Una casa di campagna, omaggio alla collezione di accessori per la casa di Mulberry, il Charlton House mette in evidenza tutte le eccentricità eleganti ed inglesi della marca. Letti a baldacchino, vasche da bagno in rame e camere con giardini segreti sono unite da splendidi velluti e merci in pelle lavorate a mano.

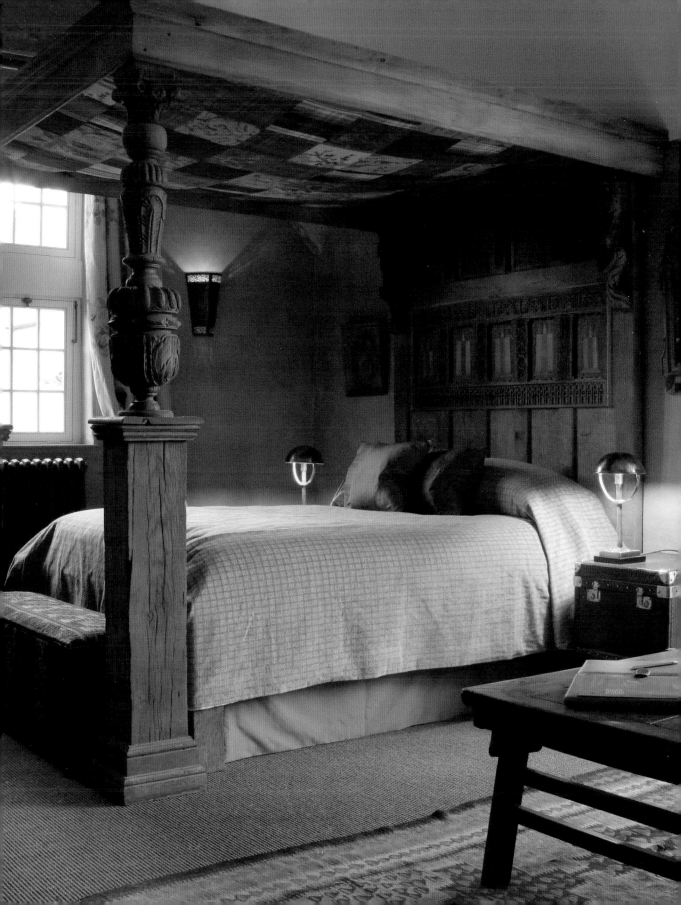

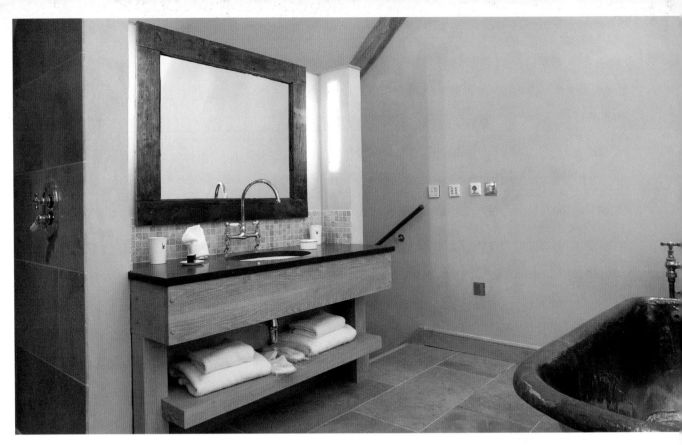

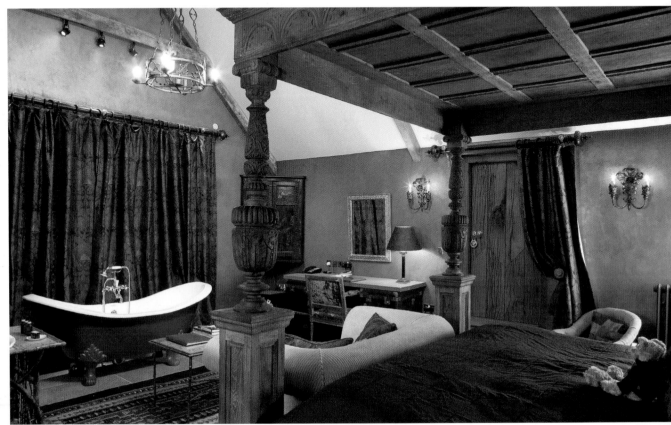

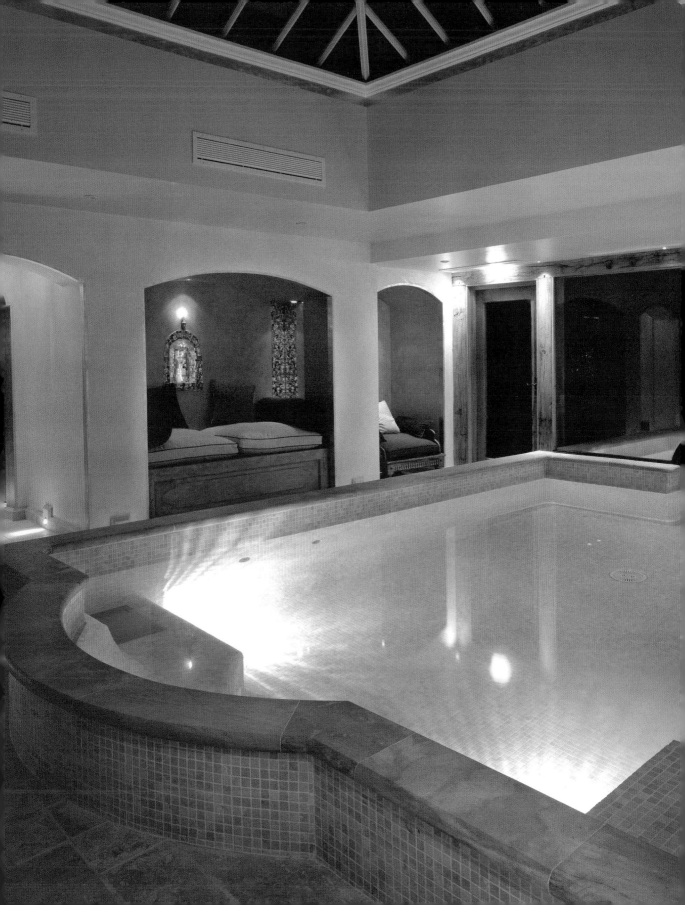

Continentale

Vicolo dell'Oro, 6r • 50123 Florence • Italy • www.lungarnohotels.com

2003
Michele Bönan
www.douglaswallace.com
Photos: courtesy Lungarno Hotels

Like a favorite pair of special occasion high heels, the Continentale elevates you into a world of luxurious fantasy. The world of Ferragamo. A place of quality fabrics and finishes within the feminine pastel to pop art interiors of Michele Bönan.

Wie das Lieblingspaar High Heels zu besonderen Gelegenheiten versetzt einen auch das Continentale in eine Welt luxuriöser Fantasie, die Welt von Ferragamo. An diesem Ort existieren hochwertige Stoffe und Oberflächen in femininen Pastelltönen neben Pop-Art-Interieurs von Michele Bönan.

Comme une paire préférée de chaussures à talons hauts réservée aux occasions spéciales, le Continentale vous élève vers un monde de fantaisies luxueuses. Le monde de Ferragamo. Un endroit de tissus et de finitions de qualité dans les tons pastel féminins côtoyant des intérieurs Pop Art de Michele Bönan.

Al igual que si llevara sus zapatos de tacones altos preferidos para una ocasión especial, el Continentale le dará la sensación de ser transportado a un mundo de lujosa fantasía: el mundo de Ferragamo. En este lugar hay materiales y superficies de gran valor en tonos pastel femeninos junto a la decoración de interiores al estilo Pop Art de Michele Bönan.

Come un paio di scarpe preferite a tacchi alti per le occasioni speciali, il Continentale Vi eleverà in un mondo di fantasie lussuose. Il mondo di Ferragamo. Un luogo di tessuti di qualità e finiture con pastelli femminili fino agli interni nello stile pop art di Michele Bönan.

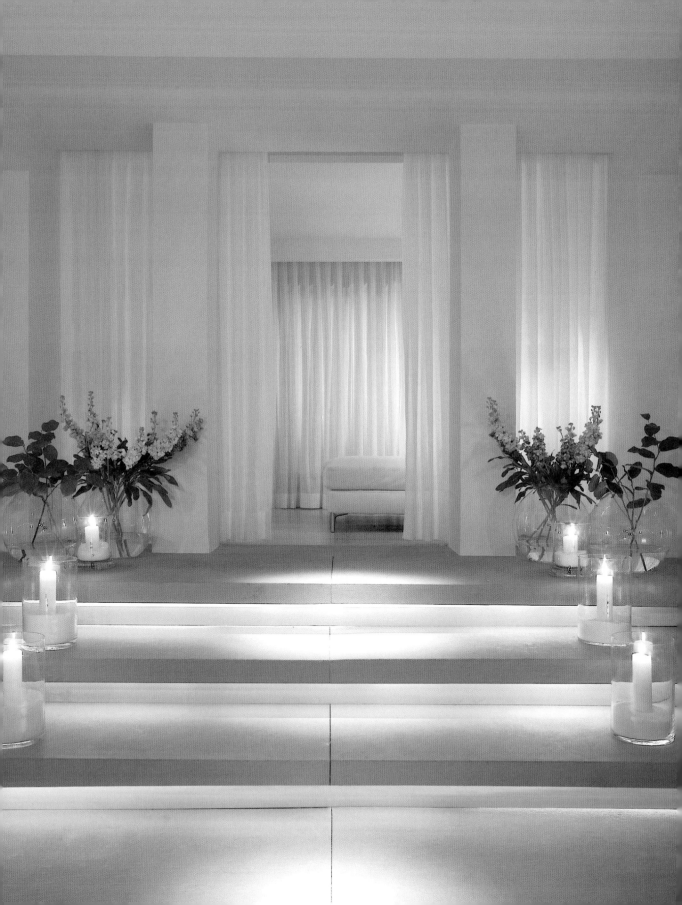

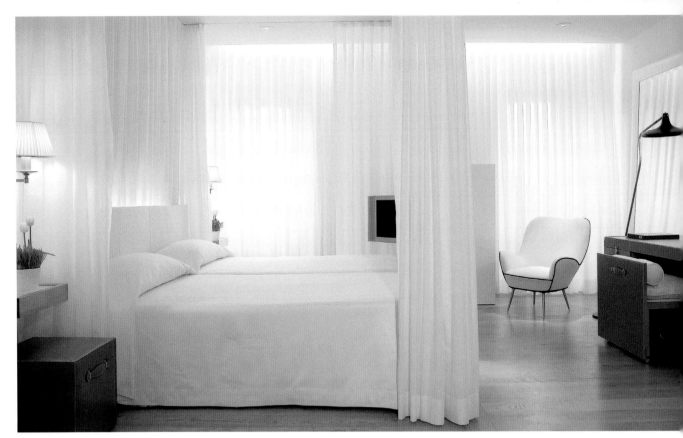

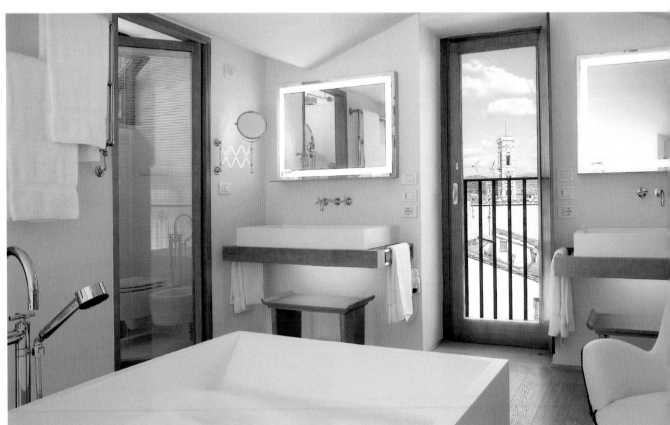

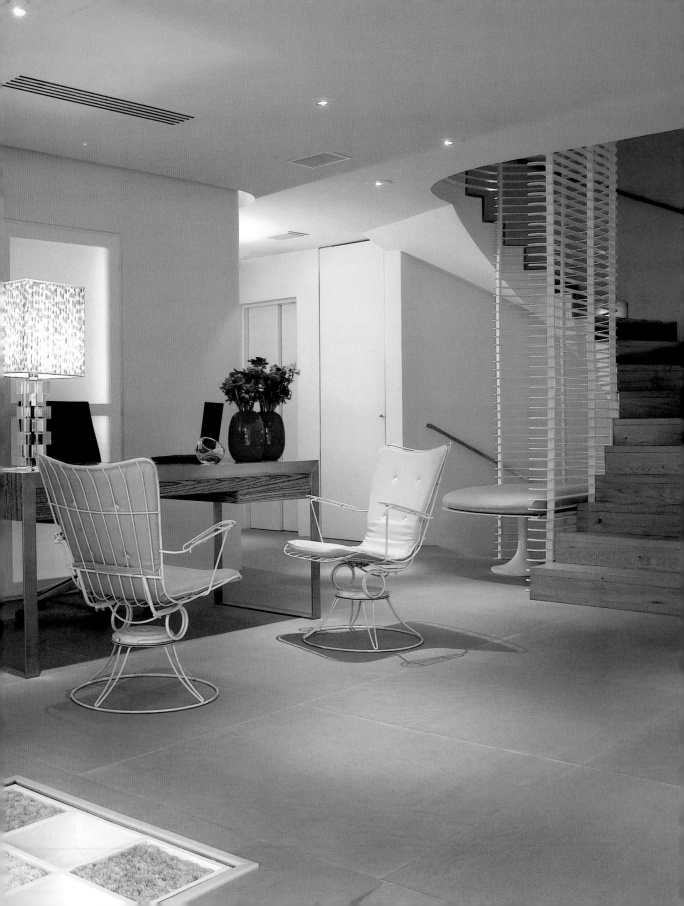

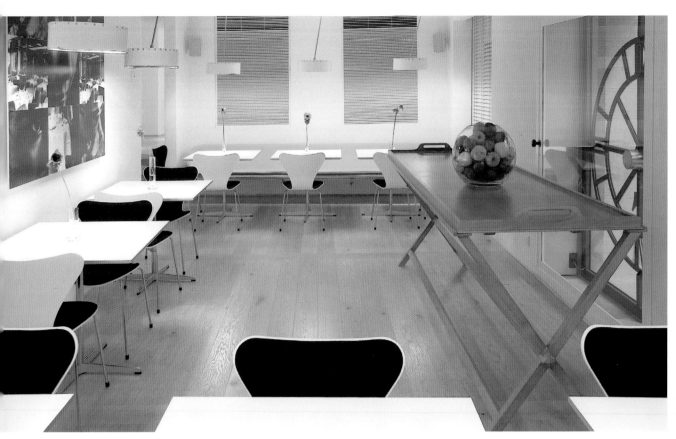

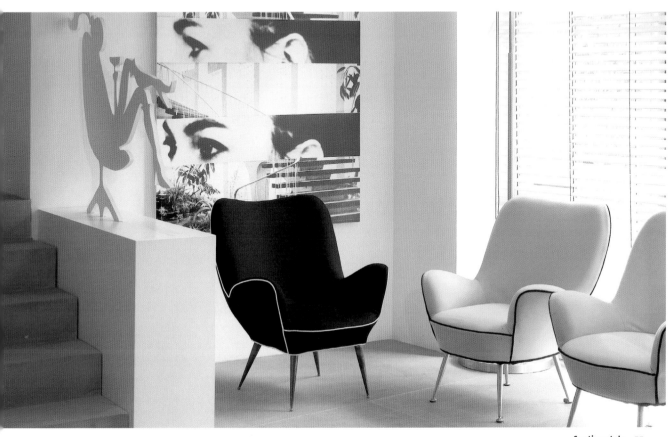

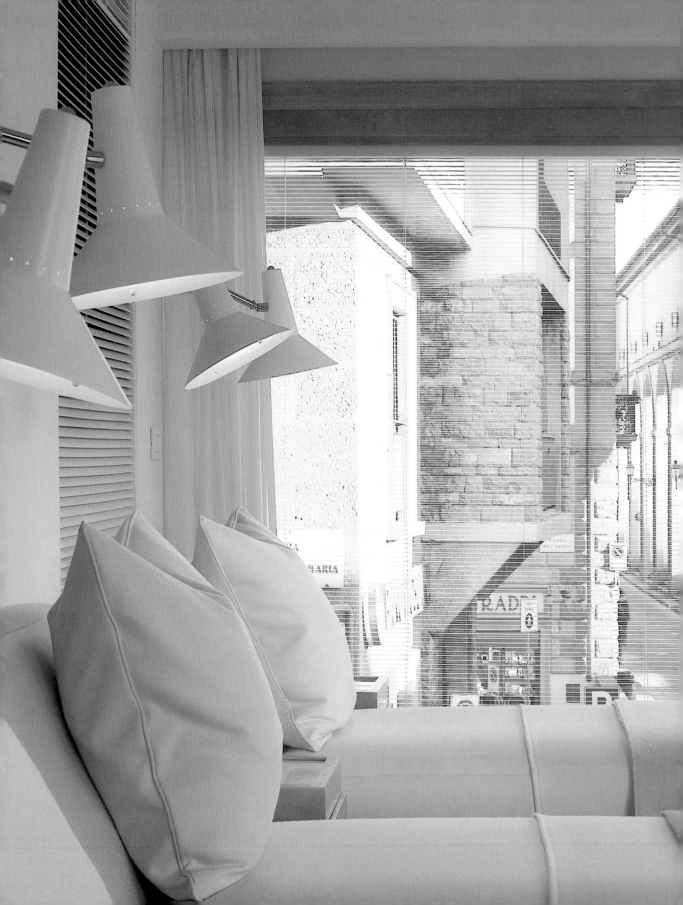

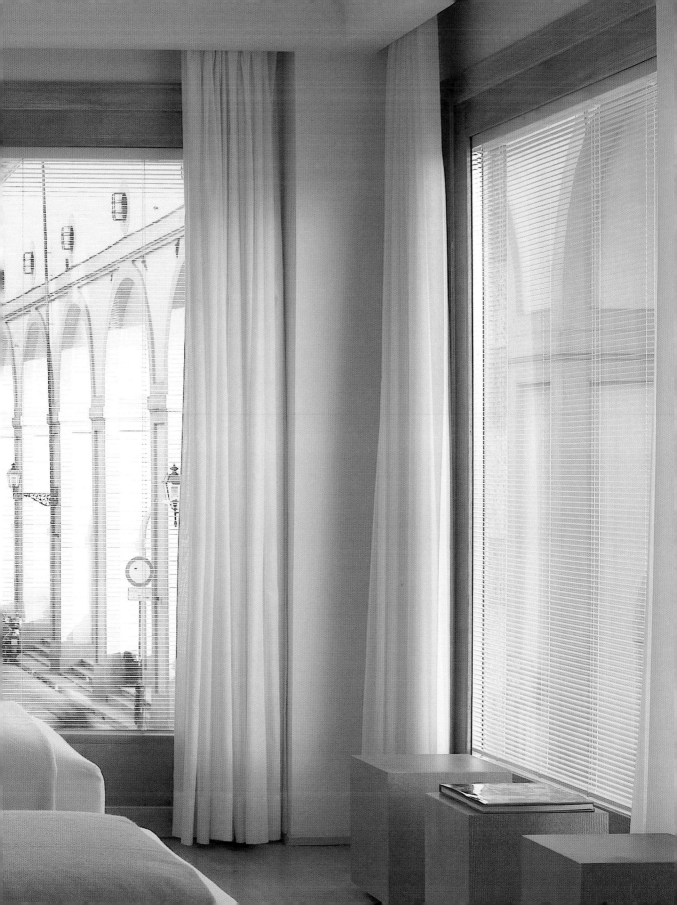

Hotelito Desconocido

Puerto Vallarta, Jalisco Mexico • 48350 Puerto Vallarta, Jalisco • Mexico • www.hotelito.com

1996

Marcello Murzilli

Photos: Martin Nicholas Kunz

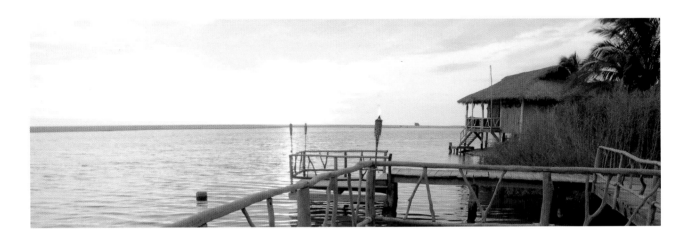

The bamboo screens and palm thatching of the *palafitos* are representative of the harmonious relationship with nature of this secluded Pacific beachfront hotel. Marcello Murzilli cashed in part of his Charro jeans label to fulfill a dream where luxury is less rather than more.

Die Bambus-Trennwände und Palmdächer der *palafitos* sind für die harmonische Beziehung zwischen Natur und diesem abgelegenen Hotel am Pazifikstrand repräsentativ. Marcello Murzilli investierte Erlöse aus seinem Jeanslabel Charro, um einen Traum zu verwirklichen, in dem der Luxus darin besteht, dass weniger mehr ist.

Les écrans en bambou et les toits en feuilles de palmiers des *palafitos* sont représentatifs de la relation harmonieuse avec la nature qu'affiche cet hôtel sur le Pacifique. Marcello Murzilli a investi une partie des revenus issus de sa marque de jeans Charro pour parachever un rêve dans lequel le luxe est plutôt moins que plus.

Los tabiques de bambú y techos de palmera de los palafitos representan la relación armónica entre la naturaleza y este hotel apartado, situado en la playa del Pacífico. Marcello Murzilli invirtió una parte de sus ingresos en su marca de pantalones, Charro, para hacer realidad un sueño, en el que el lujo es minimalista.

I pannelli in bambù e coperture di palme dei *palafitos* sono rappresentativi per il rapporto armonico con la natura di questo hotel nascosto che si trova di fronte alla spiaggia del Pacifico. Marcello Murzilli ha investito una parte dei ricavi della sua marca di jeans Charro per soddisfare un sogno nel quale il lusso significa meno che di più.

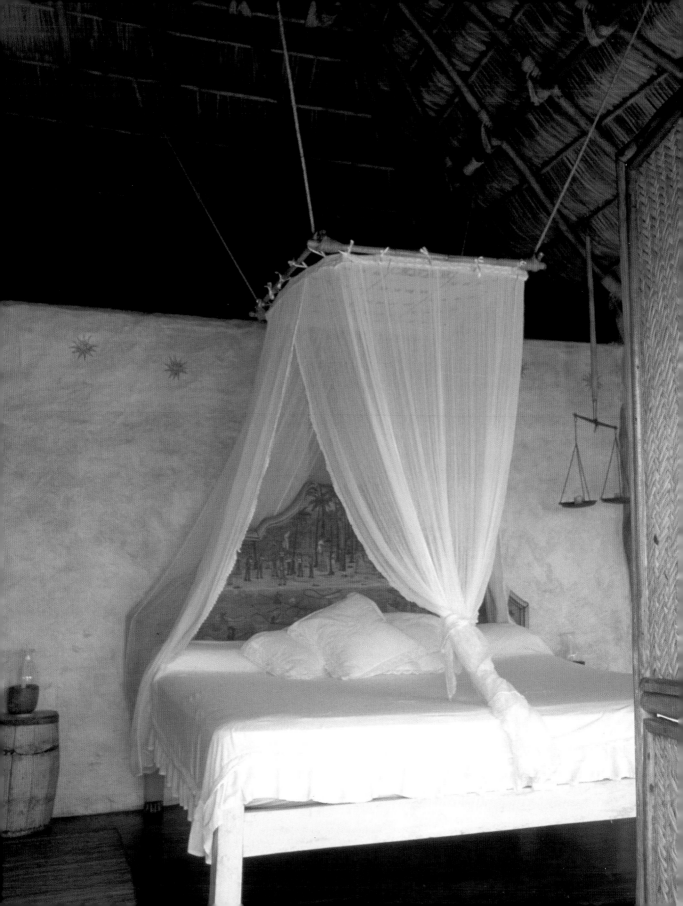

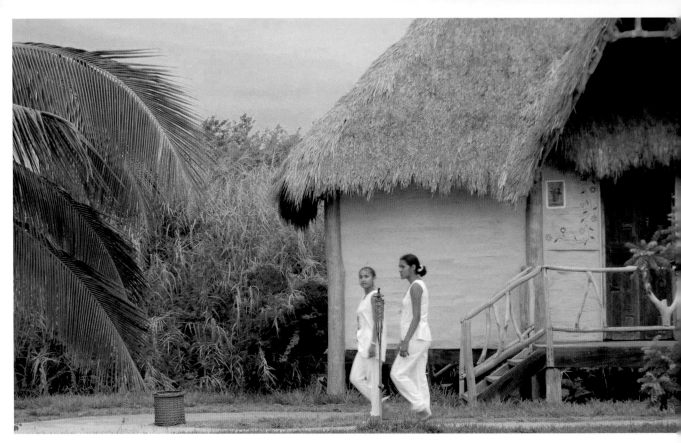

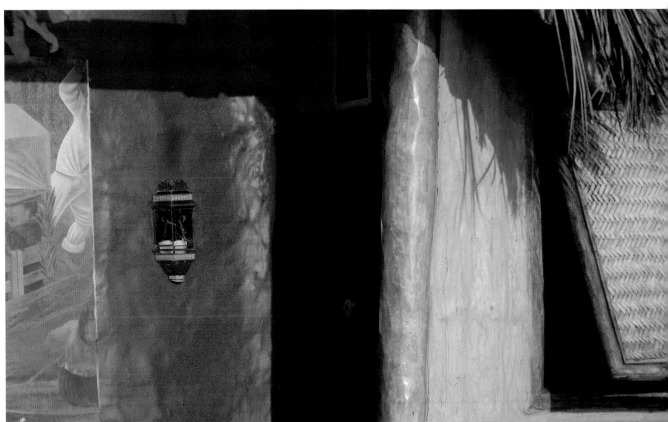

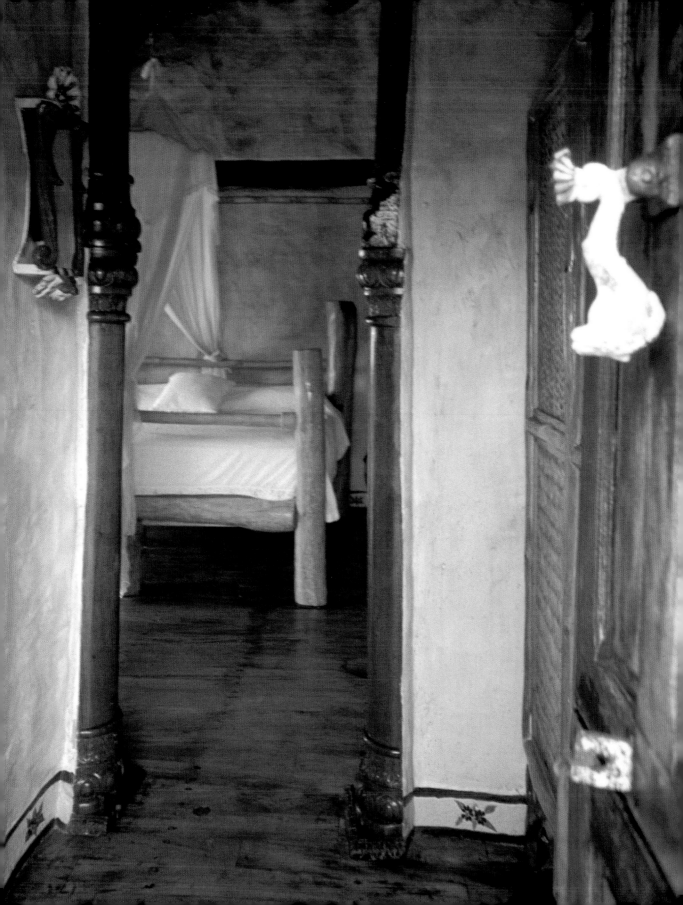

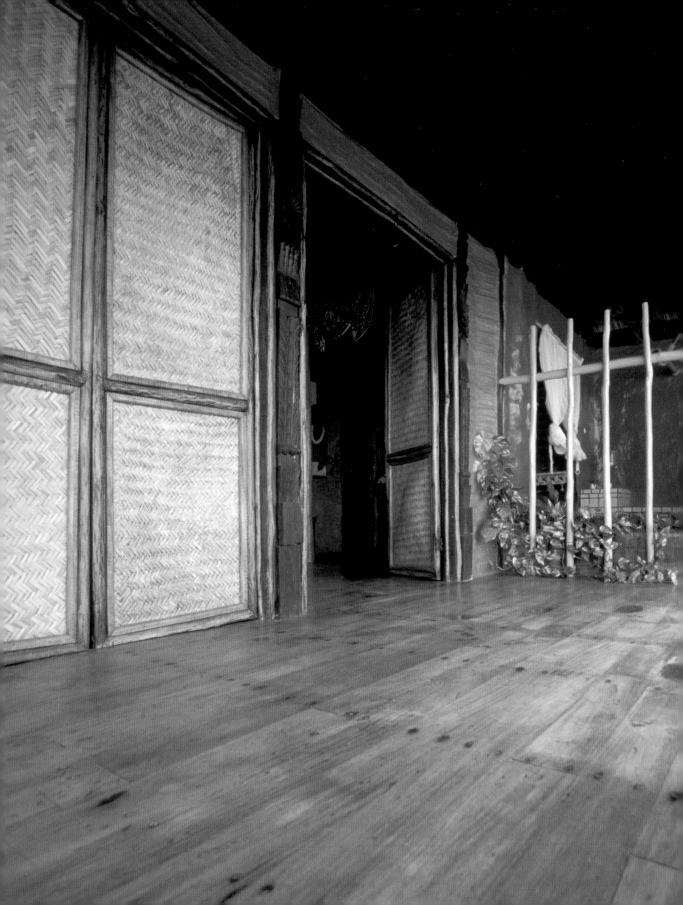

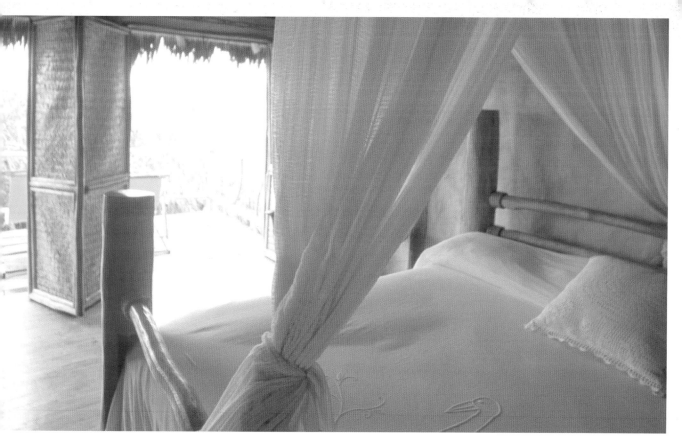

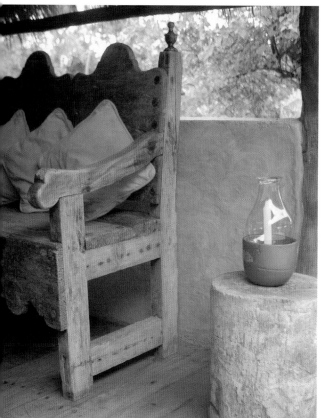

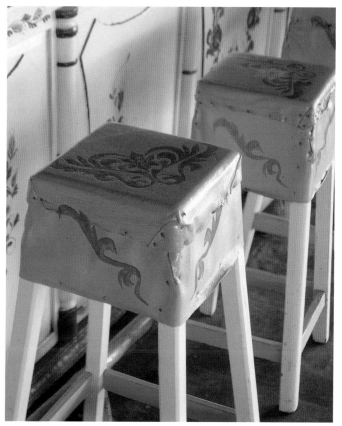

Faena Hotel + Universe

Martha Salotti 445 • C1107CMB Buenos Aires • Argentina

www.faenahotelanduniverse.com

2004

Philippe Starck Network

www.philippe-starck.com

Photos: Katharina Feuer, Nikolas Koenig, courtesy Faena Hotel + Universe

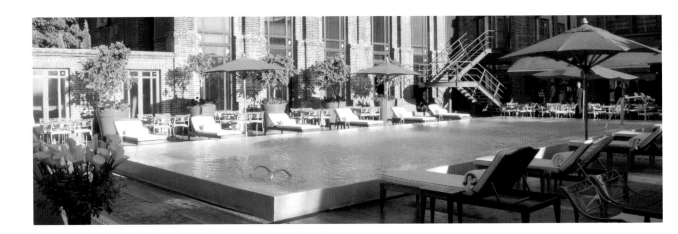

Contemporary lavishness and imperial extravagance typify the eponymous hotel of Argentinean fashion designer Alan Faena. Together with Philippe Starck they have created an expectedly immodest and gauche landmark, set to revitalize a run down area of Buenos Aires.

Zeitgenössische Großzügigkeit und imperiale Extravaganz sind typisch für das gleichnamige Hotel des argentinischen Modeschöpfers Alan Faena. Zusammen mit Philippe Starck errichtete er ein erwartungsgemäß unbescheidenes und wenig taktvolles Wahrzeichen, um eine heruntergekommene Gegend in Buenos Aires wiederzubeleben.

Le faste contemporain et l'extravagance impériale sont typiques pour cet hôtel éponymique du créateur de mode argentin Alan Faena. Ensemble avec Philippe Starck ils ont crée un jalon immodeste et gauche comme on pouvait l'escompter, créé pour revitaliser une zone décrépite de Buenos Aires.

La generosidad contemporánea y la extravagancia imperial son típicas en este hotel que lleva el mismo nombre que el del diseñador de moda argentino Alan Faena. Como era de esperar, junto a Philippe Starck creó una marca distintiva atrevida e indiscreta para resucitar una zona bonaerense venida a menos.

Lusso contemporaneo e stravaganza imperiale caratterizzano quest'hotel eponimo del designer di moda argentino Alan Faena. Assieme a Philippe Starck essi hanno creato un pezzo di terra aspettatamente poco modesto e privo di tatto, creato per ridare vita ad una zona trascurata di Buenos Aires.

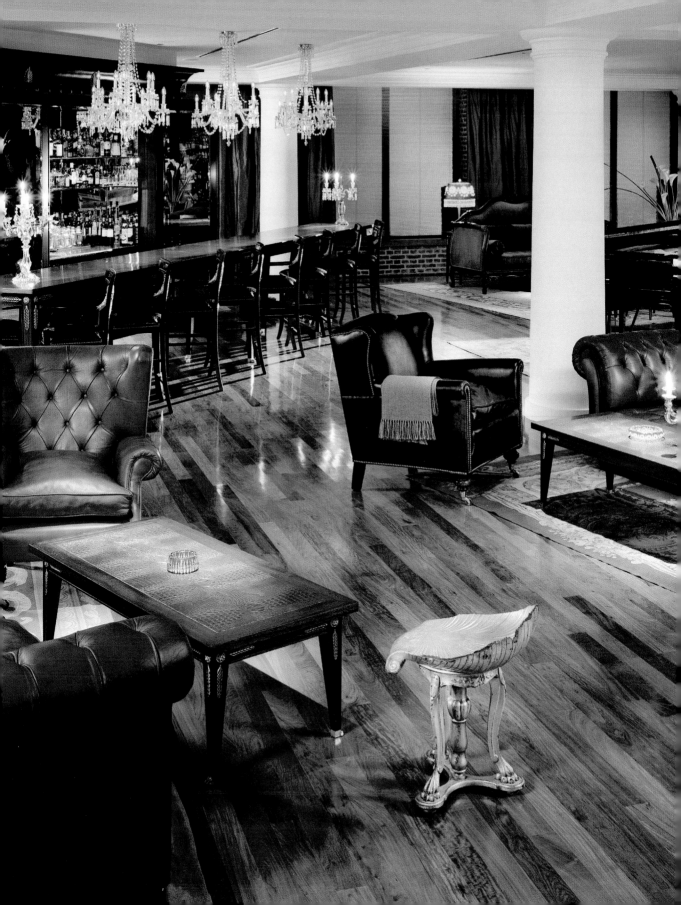

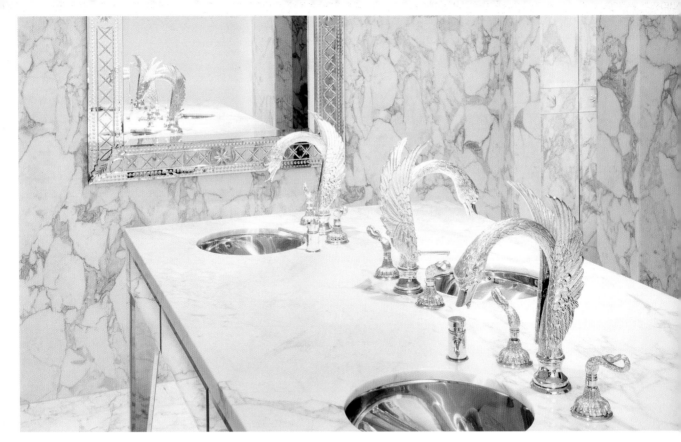

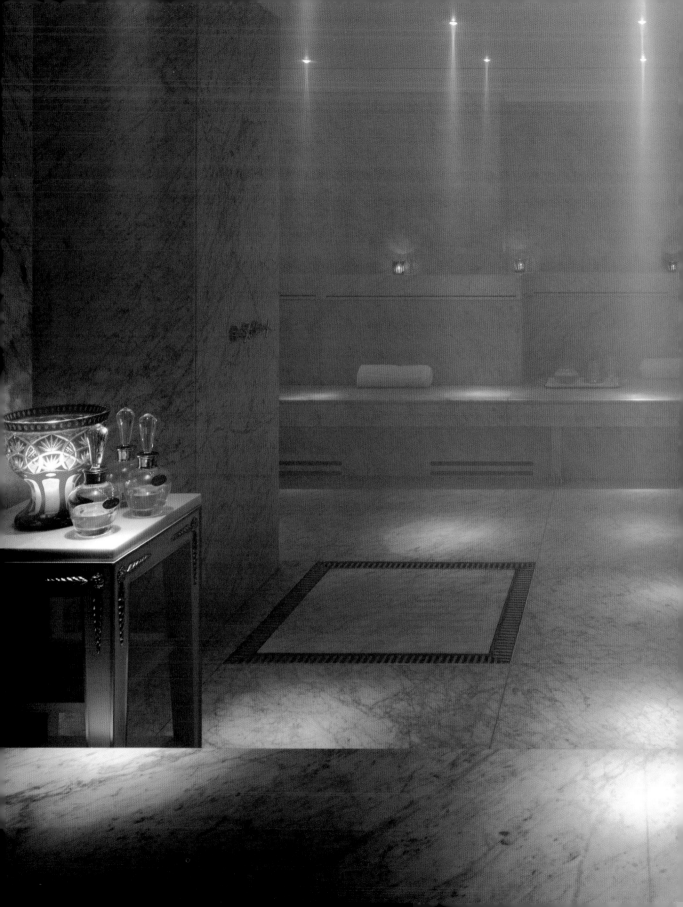

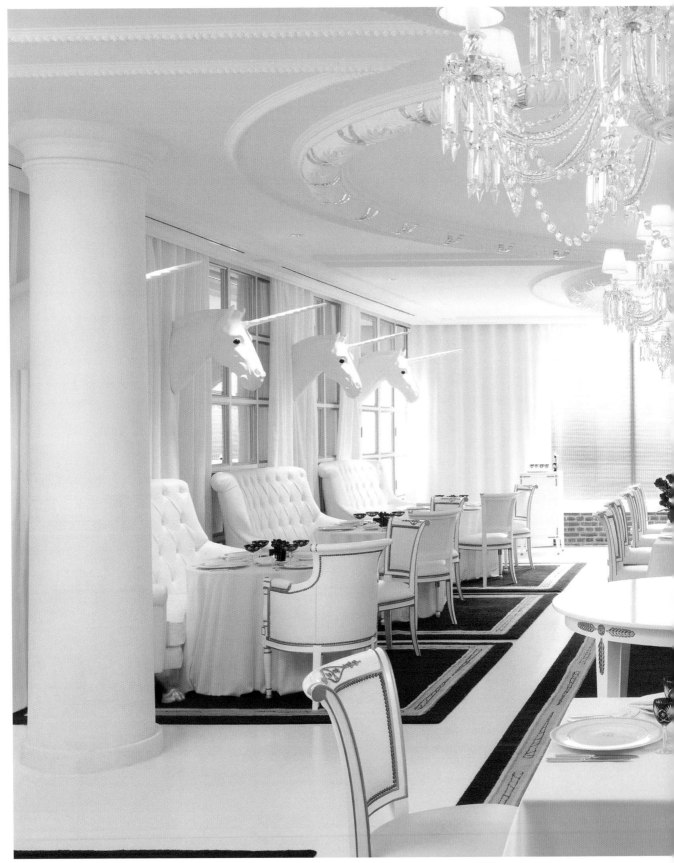

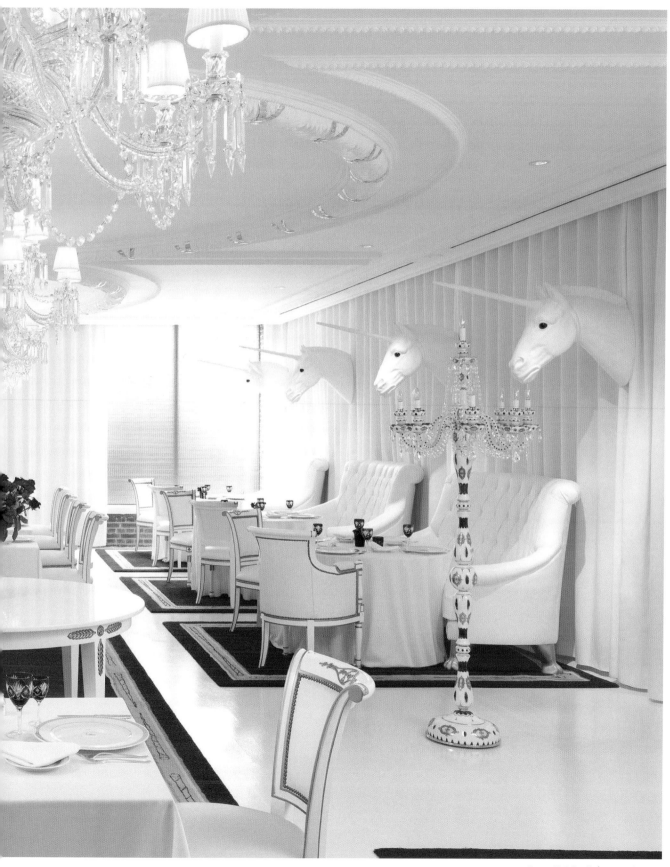

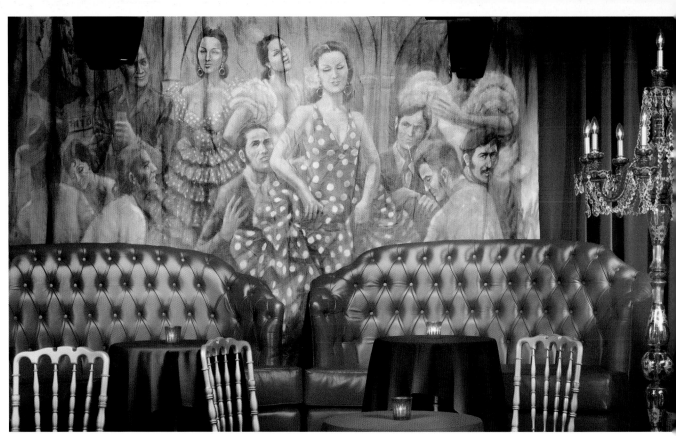

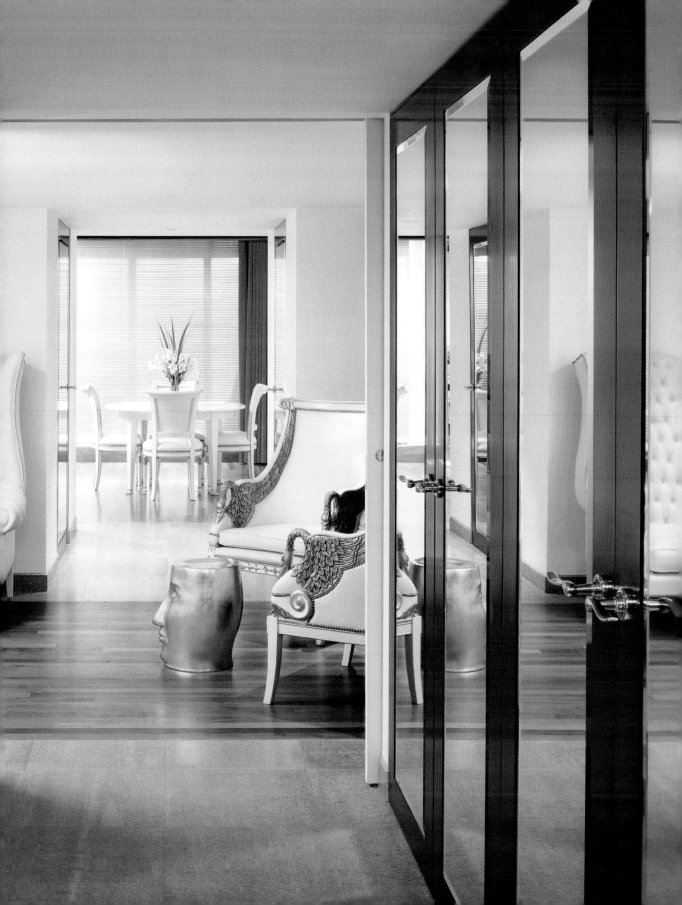

Fox Hotel

Jarmers Plads 3 • 1551 Copenhagen V • Denmark • www.hotelfox.dk

2005
Various
www.eventlabs.de
Photos: Christoph Kraneburg, Projekt Fox

With an open brief, twenty-one young international creatives fashioned a gallery of a hotel with a street art vibe. No room is alike in this crazy and innovative approach to interior design. Each has a personal touch testified by the artists' signatures.

Mit einem offen formulierten Auftrag gestalteten einundzwanzig junge internationale Designer die Galerie unter den Hotels mit Straßenkunstatmosphäre. Kein Zimmer ähnelt dem anderen in diesem verrückten und innovativen Designansatz. Jeder Raum hat eine persönliche Note, bezeugt durch die Unterschriften der Künstler.

Suite à un appel ouvert, vingt et un jeunes créateurs internationaux ont conçu un hôtel comme une galerie du style Street Art. Aucune chambre ne ressemble aux autres dans cette approche folle et innovante de design d'intérieur. Chacune dispose d'une touche personnelle certifié par la signature du créateur.

Mediante un concurso público, veintiún jóvenes diseñadores de talla internacional diseñaron una vera galeria entre los hoteles, impregnándola de un ambiente artístico callejero. No hay lugar para dos habitaciones iguales en este concepto de decoración innovativo y loco. Cada espacio tiene un matiz peculiar que es testigo del toque personal de los artistas.

Con una commissione aperta, ventuno giovani creativi internazionali hanno creato una vera galleria tra gli hotel con un'atmosfera dell'arte di strada. Nessuna camera è uguale all'altra in questo approccio pazzo e innovativo al design d'interni. Ogni camera presenta un tocco personale, come testimoniano le firme degli artisti.

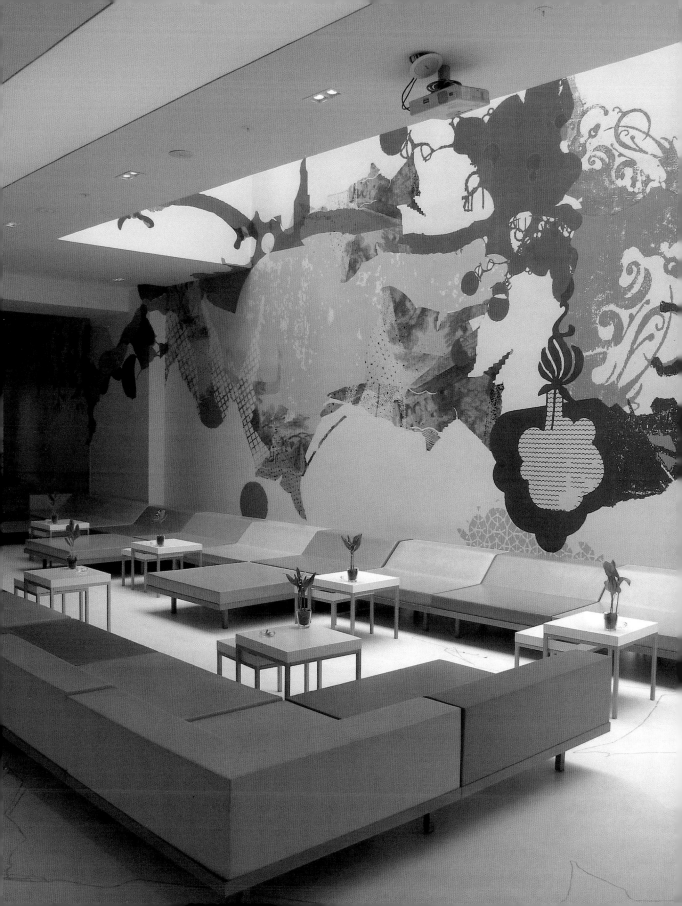

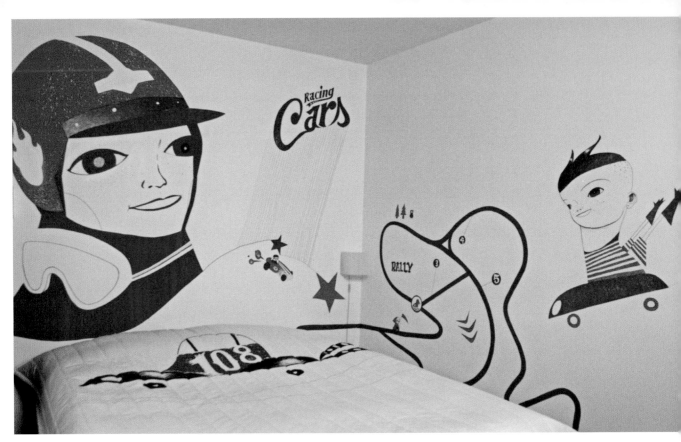

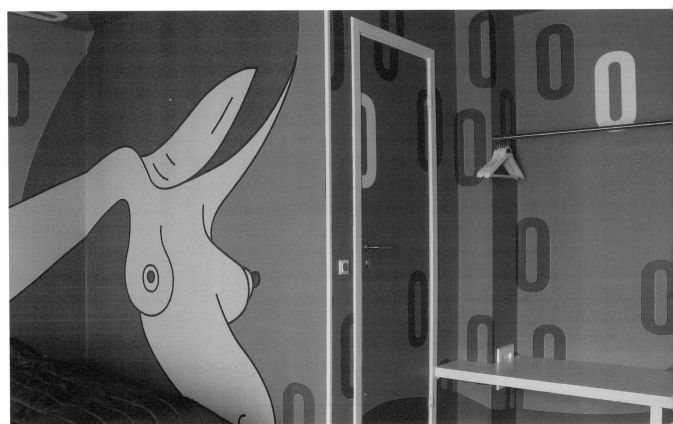

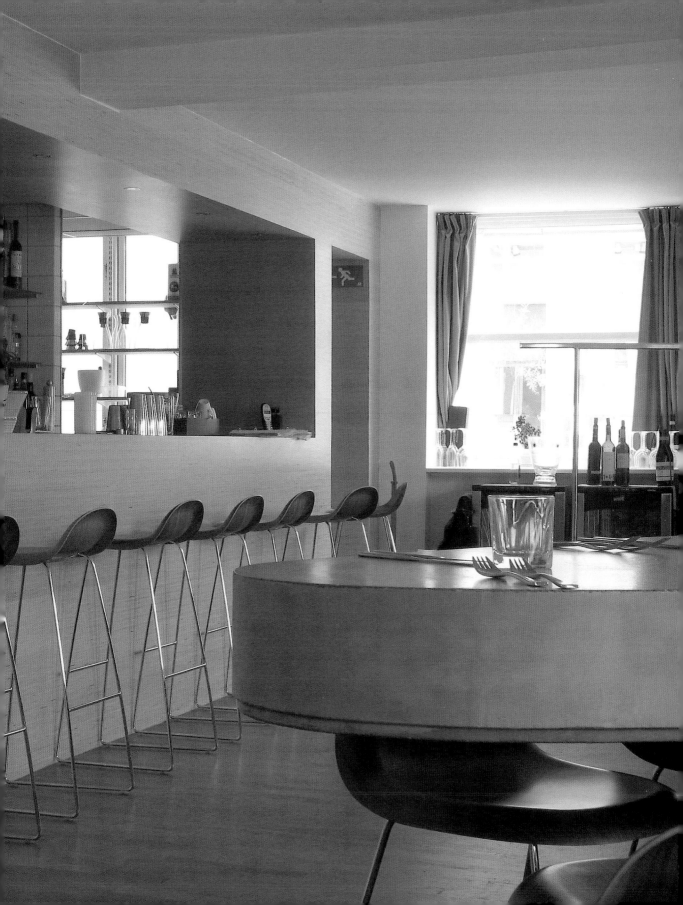

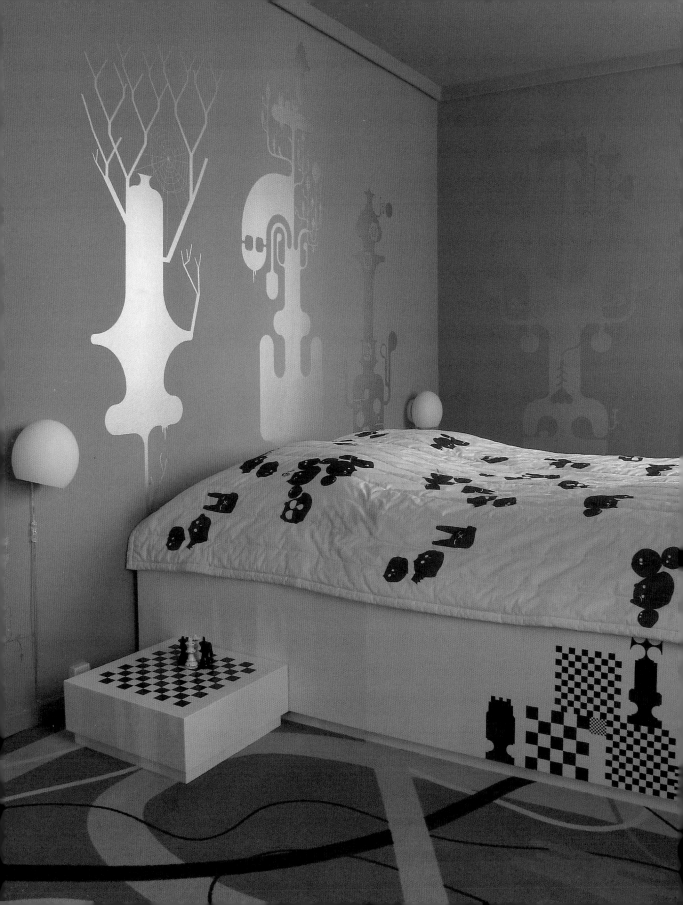

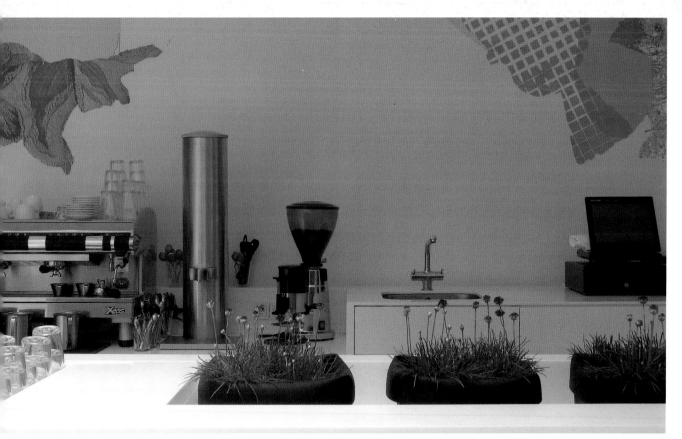

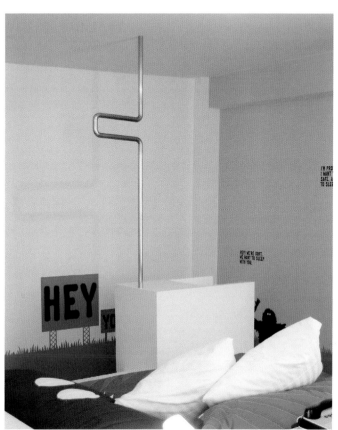

82% of all European hotel rooms feature a romantic landscape painting

Last year
of 10 peo
that this be
firm enough
out of 10 sa
that the bed
too soft. The
had absolutel
no opinion

HEY

YO

HEY! WE'RE SOFT.
WE WANT TO SLEEP
WITH YOU.

I'M PRO
I WANT
SAFE. A
TO SLEE

the g

19 Eyre Square • Galway, Co Galway • Ireland • www.theghotel.ie

2005

Douglas Wallace Architects and Designers

Photos: courtesy the g (James Balston / Luke White)

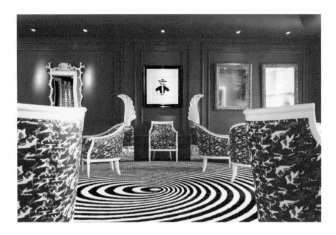

Milliner to the stars, Philip Treacy, evokes boyhood memories from visits to Galway's beach in the sea motifs at the g. The hotel is an entertaining visual spectacle from the flowing flourishes of the custom designed door handles to the use of vibrant pinks and blues.

Der Modist der Stars, Philip Treacy, ruft mit den Meeresmotiven im the g Kindheitserinnerungen an Besuche an Galways Strand hervor. Das Hotel ist ein unterhaltsames visuelles Spektakel, vom fließenden Schwung der speziell angefertigten Türgriffe bis zur Verwendung knalliger Pink- und Blautöne.

Modiste de stars, Philip Treacy évoque des souvenirs de jeune garçon issus de visites à la plage de Galway dans les motifs marins du the g. L'hôtel est un spectacle visuel intéressant, des fioritures drapées aux poignées de portes créées sur mesure, à l'utilisation de roses et de bleus vibrants.

En the g, el modisto de las estrellas, Philip Treacy, evoca con sus motivos marinos recuerdos de la infancia de estancias en la playa Galway. El hotel ofrece un espectáculo entretenido que abarca desde el dinamismo fluido de los pomos de diseño especial hasta el uso de vibrantes tonos rosas y azules.

Uno che veste le star, Philip Treacy, evoca memorie della gioventù dalle visite alla spiaggia di Galway con motivi di mare nel the g. L'hotel è uno spettacolo dell'intrattenimento dai tocchi scorrevoli delle maniglie delle porte fatte su misura secondo i desideri del cliente fino all'uso di colori rosa vibrante e di blu.

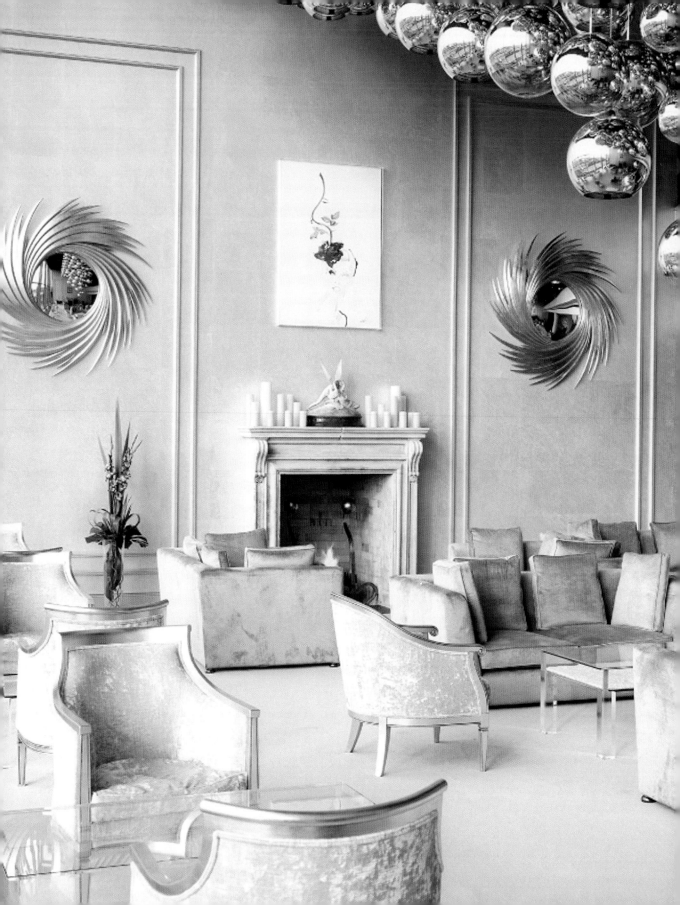

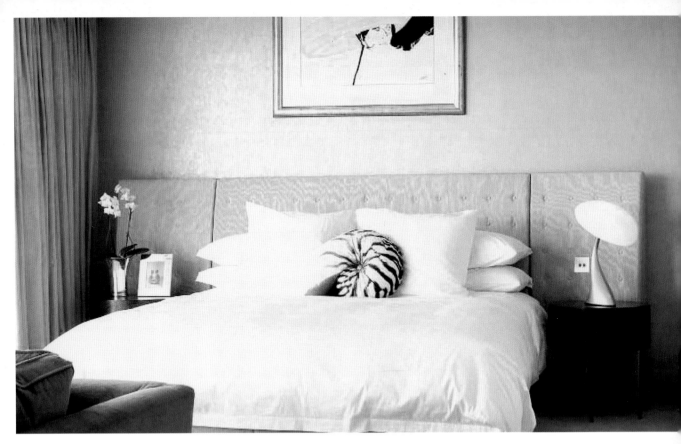

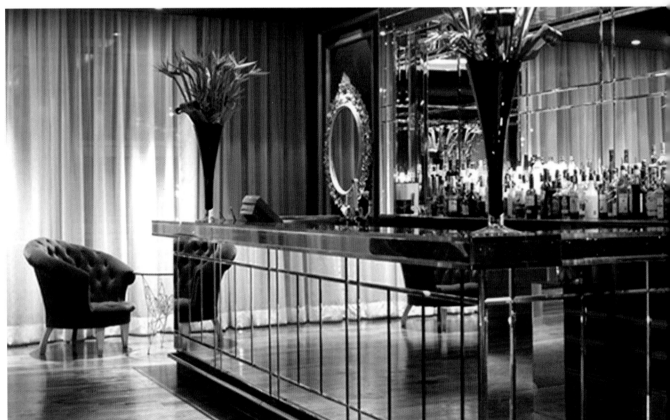

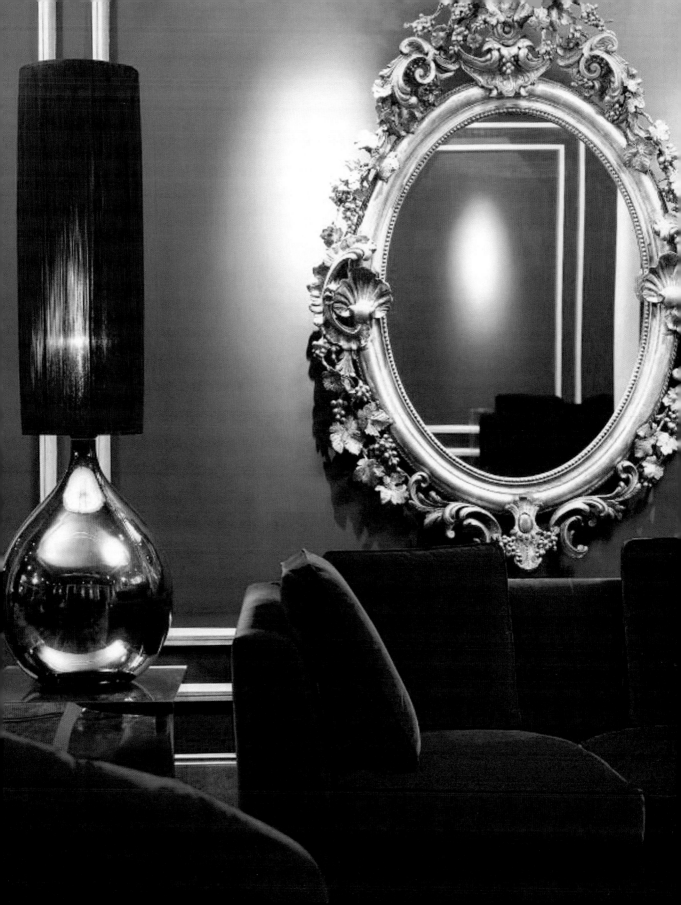

Gallery Hotel Art

Vicolo dell'Oro, 5 • 50123 Florence • Italy • www.lungarnohotels.com

1999

Michele Bönan

www.douglaswallace.com

Photos: courtesy Lungarno Hotels

 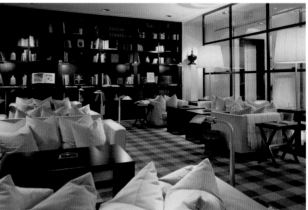

The beautiful craftsmanship seen in the leatherwork of Ferragamo's shoes and accessories is seen here in the quality detailing of the hotel's leather and casework. The somewhat masculine style is reassuringly seductive in a timeless way.

Die exquisite, in der Lederarbeit von Ferragamos Schuhen und Accessoires sichtbare Kunstfertigkeit zeigt sich in den hochwertigen Details der Leder- und Holzarbeiten im Inneren des Hotels. Der etwas maskuline Stil wirkt auf zeitlose Art gleichzeitig beruhigend und verführerisch.

Le très beau travail d'artisan pour lequel les chaussures et accessoires de Ferragamo sont connus se retrouve ici dans la qualité des détails des cuirs et des revêtements de l'hôtel. Le style quelque peu masculin est séduisant et rassurant d'une façon intemporelle.

La maravillosa habilidad artística de Ferragamo, que se aprecia en el tratamiento del cuero en sus zapatos y accesorios, se muestra también en los valiosos detalles trabajados en cuero y en trabajos particulares en madera de este hotel. El estilo, algo masculino, es tranquilo, seductor y, de alguna manera, intemporal.

Il fantastico artigianato visibile nel lavoro di cuoio delle scarpe e degli accessori di Ferragamo si ritrova qui nei dettagli di qualità del cuoio e del lavoro su legno dell'hotel. Lo stile, in qualche modo masculino, è seduttivo in un modo rassicurante e senza tempo.

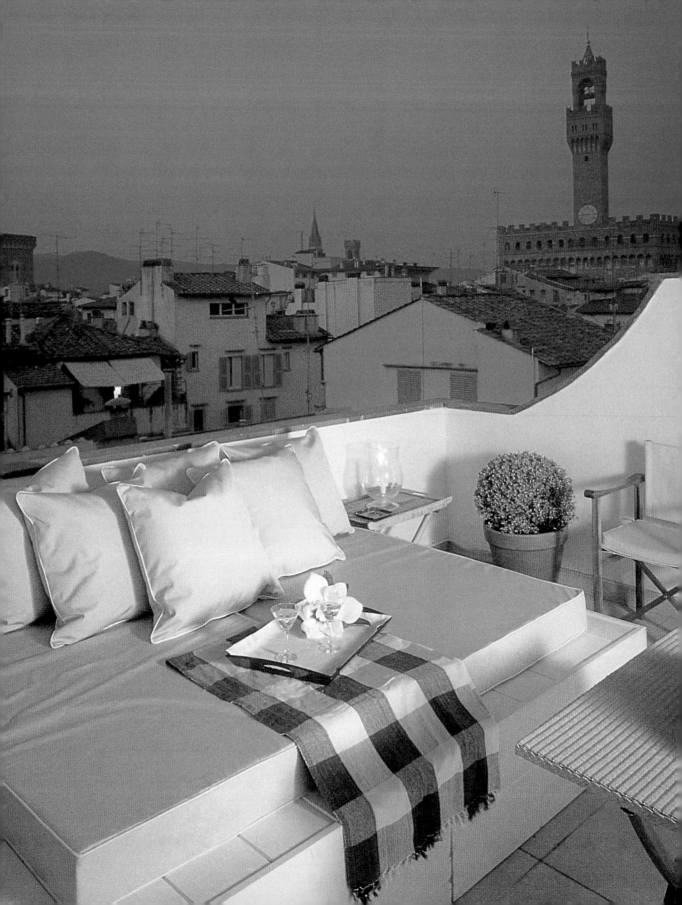

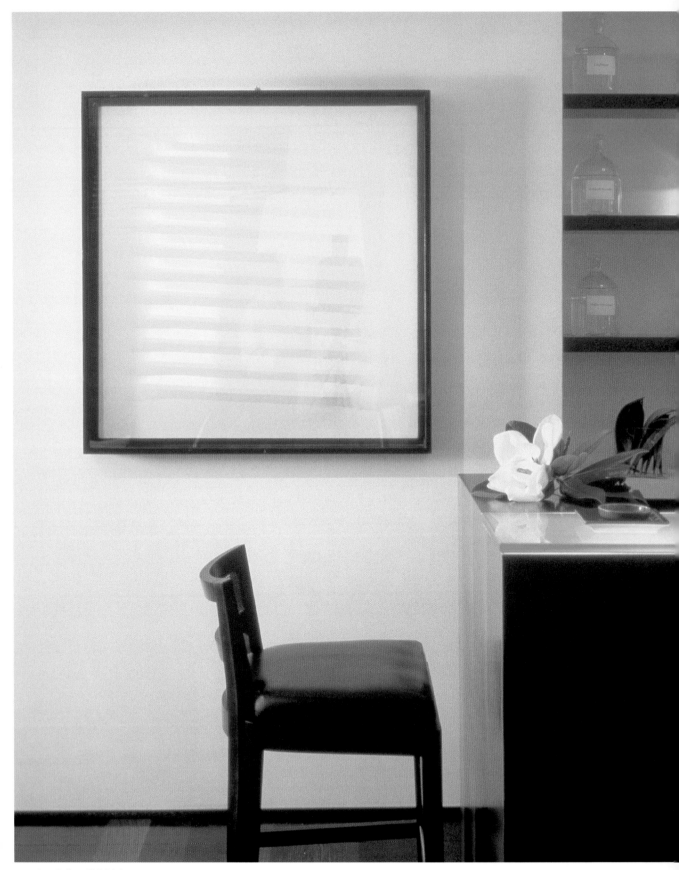

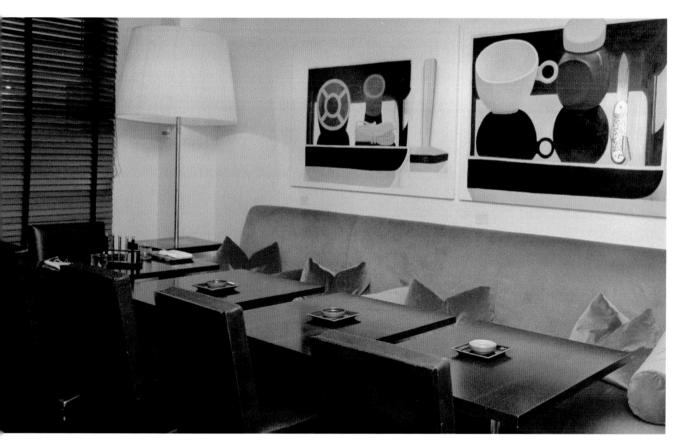

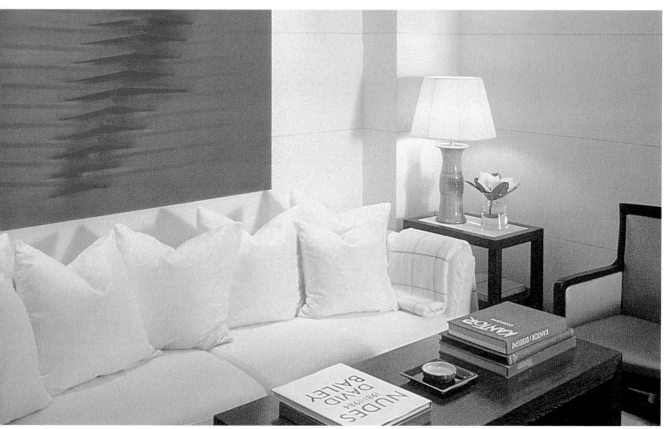

The Hotel of South Beach

801 Collins Avenue · Miami Beach, Florida 33139 · USA · www.thehotelofsouthbeach.com

Reopening 1997
Todd Oldham
www.toddoldham.com
Photos: Martin Nicholas Kunz, Michelle Galindo, courtesy The Hotel

Inspired by the colors of the original terrazzo lobby floor of this 1930's Art Deco hotel, Oldham applied his own polychromatic touch of showmanship to this glam Miami getaway. Colorful custom designed furniture and fabrics produce a playful aesthetic.

Inspiriert durch die Farben des originalen Terrazzobodens in der Lobby dieses Art-déco-Hotels aus den 1930ern, übertrug Oldham seinen eigenen polychromatischen Stil effektvoller Darbietung auf dieses glamouröse Refugium in Miami. Bunte, speziell angefertigte Möbel und Stoffe erzeugen eine verspielte Ästhethik.

Inspiré par les couleurs du sol en Terrazo d'origine du lobby de cet hôtel Art Déco des années 1930, Oldham a appliqué sa propre touche polychrome d'artiste à cet échappatoire glamoureux de Miami. Des meubles et des tissus créés sur mesure colorés produisent un esthétisme enjoué.

Inspirado por los colores del suelo original de terrazo del lobby de este hotel de los años treinta, de estilo Art Déco, Oldham transfirió a este lugar de descanso glamouroso en Miami su propio estilo policromado, presentándolo con efectos. Los muebles y los materiales coloridos y diseñados a medida dan como resultado una estética desenfadada.

Ispirandosi ai colori del pavimento originale del terrazzo della lobby di questo hotel art déco degli Anni 30, Oldham ha applicato un tocco policromatico di esibizione di questo nascondiglio glamour di Miami. Arredamenti e tessuti colorati, su richiesta del cliente, creano un'estetica giocosa.

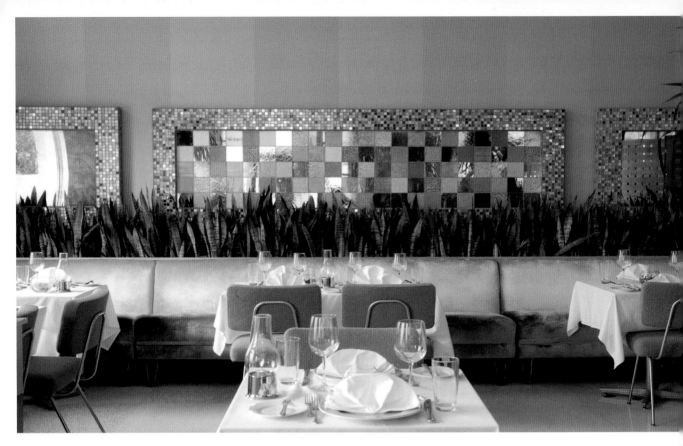

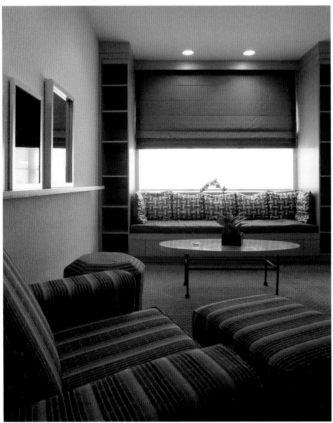

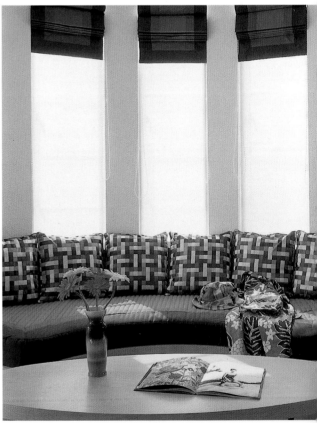

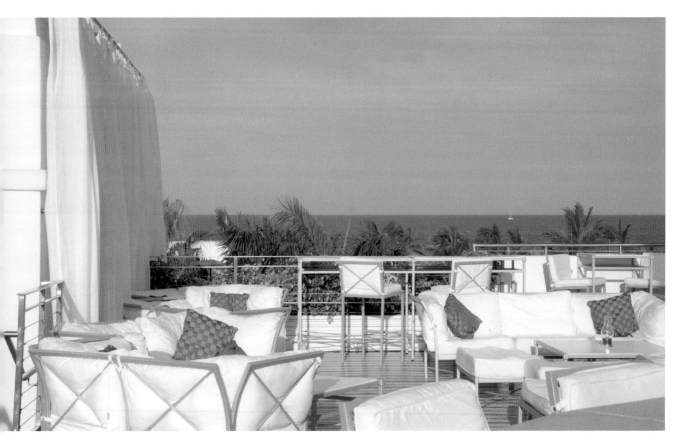

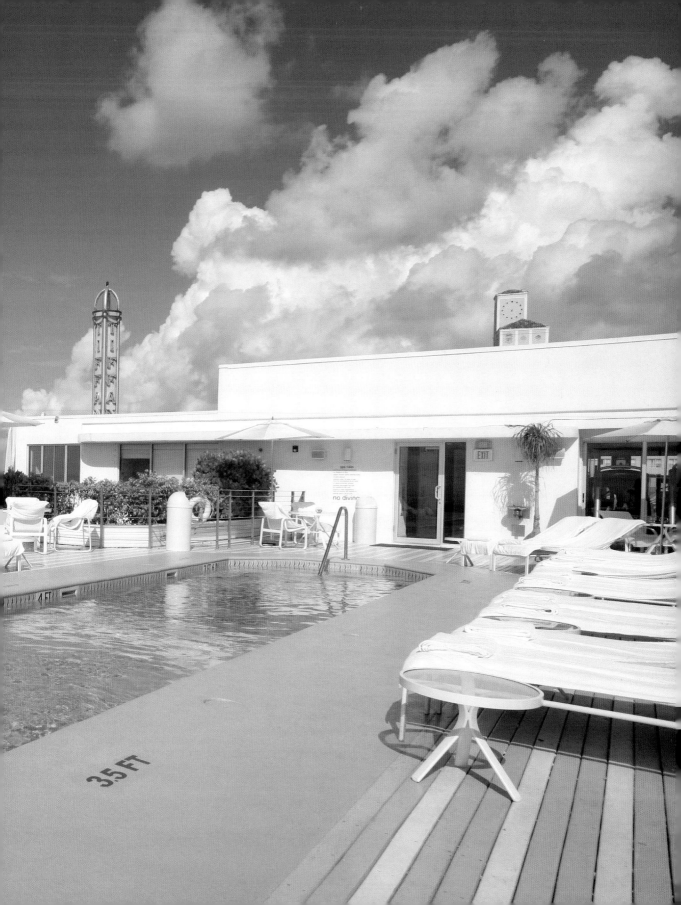

Laluna

Morne Rouge, P.O. Box 1500 • St George's • Grenada, West Indies • www.laluna.com

2000
Gabriella Giuntoli
Carmelina Santoro
Photos: Bernardo Bertucci, Martin Nicholas Kunz, courtesy Laluna

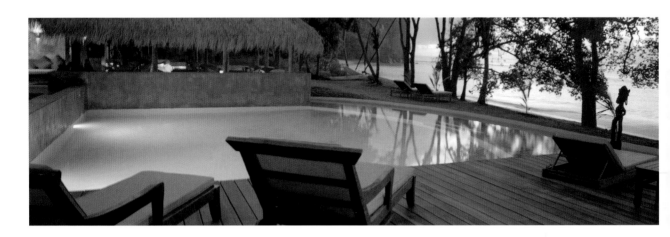

Bernardo Bertucci's close Italian fashion connections (Benetton and Zegna) generate a voguish "glamour-without-attitude" on this southwest tip of the Caribbean, the idyll of Grenada. Mediterranean lavender blues and russet siennas are the backdrop to a Balinese Caribbean style.

Bernardo Bertuccis enge Beziehungen zur italienischen Modewelt (Benetton und Zegna) drücken sich an der Südwestspitze der Karibik, im idyllischen Grenada, in aktuell angesagten, eleganten Interieurs ohne jede Affektiertheit aus. Mediterrane lavendelblaue Farbtöne und das Rotbraun der Sienaerde bilden den Hintergrund für einen balinesisch-karibischen Stil.

Les relations étroites de Bernardo Bertucci avec le monde de la mode italienne (Benetton et Zegna) génèrent un style d'intérieurs « élégants, mais sans maniérisme » très en vogue sur cette extrémité Sud-Ouest des Caraïbes qu'est l'idylle de Grenada. Des bleus lavande méditerranéens et des ocres de Sienne constituent un contraste avec le style balinais caraïbe.

Las estrechas relaciones de Bernardo Bertucci con el mundo de la moda italiano (Benetton y Zegna) dieron como resultado un interior elegante actual sin ningún tipo de artificialidad en la punta suroeste del Caribe, en la idílica isla de Granada. Los tonos mediterráneos azul lavanda y el marrón amarillento de la tierra de Siena dan trasfondo a un estilo caribeño balinés.

I stretti legami di Bernado Bertucci con il mondo della moda italiano (Benetton e Zegna) generano un'attitudine in vogue "glamour-senza-posizione" su questa punta a sud-ovest dei Caraibi, l'idillio di Grenada. Blu lavanda del Mediterraneo e colori in rosso-marrone sienna rappresentano il ritorno ad uno stile caraibico di Bali.

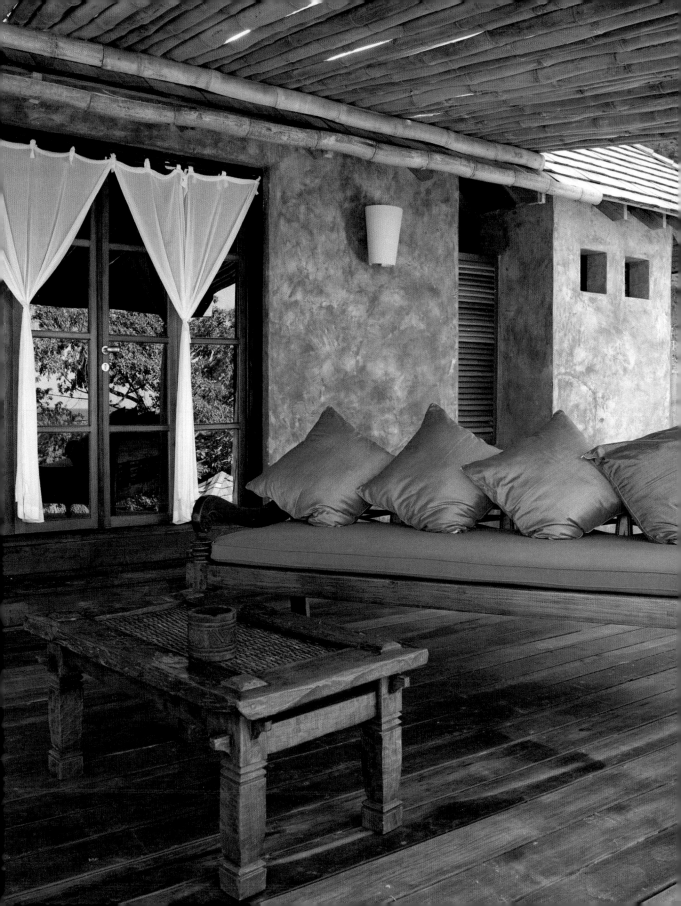

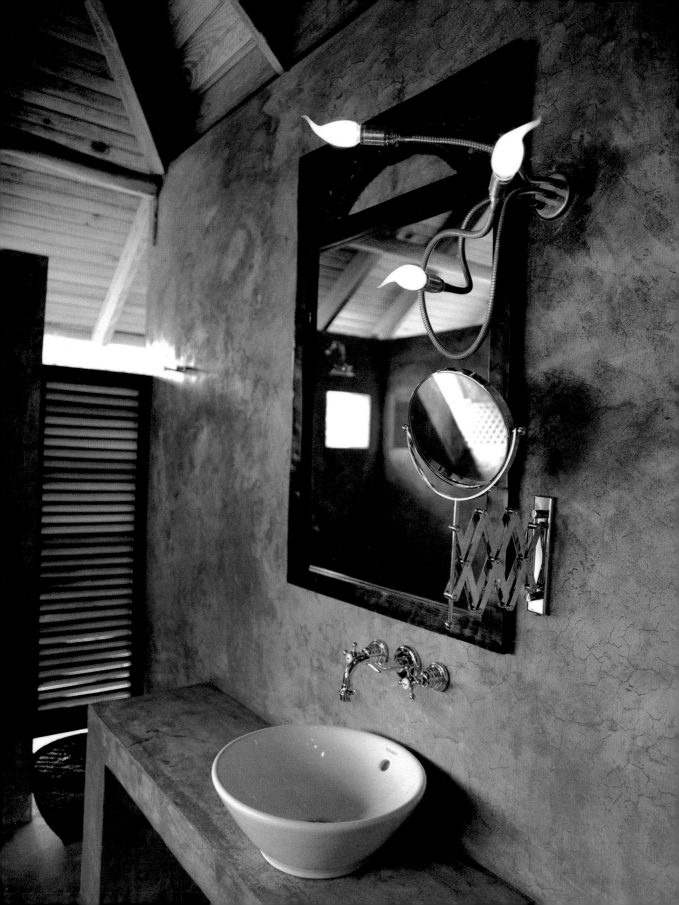

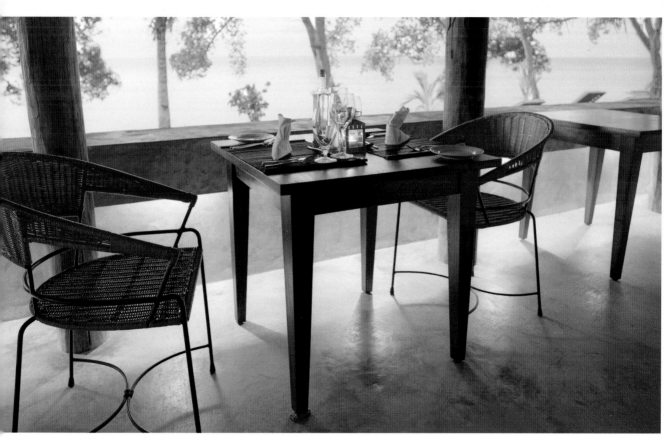

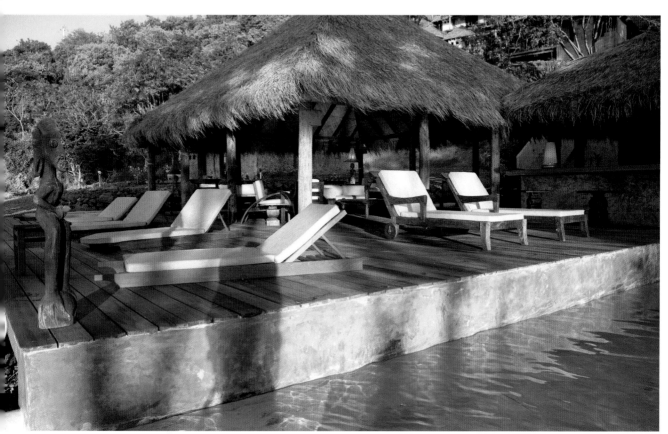

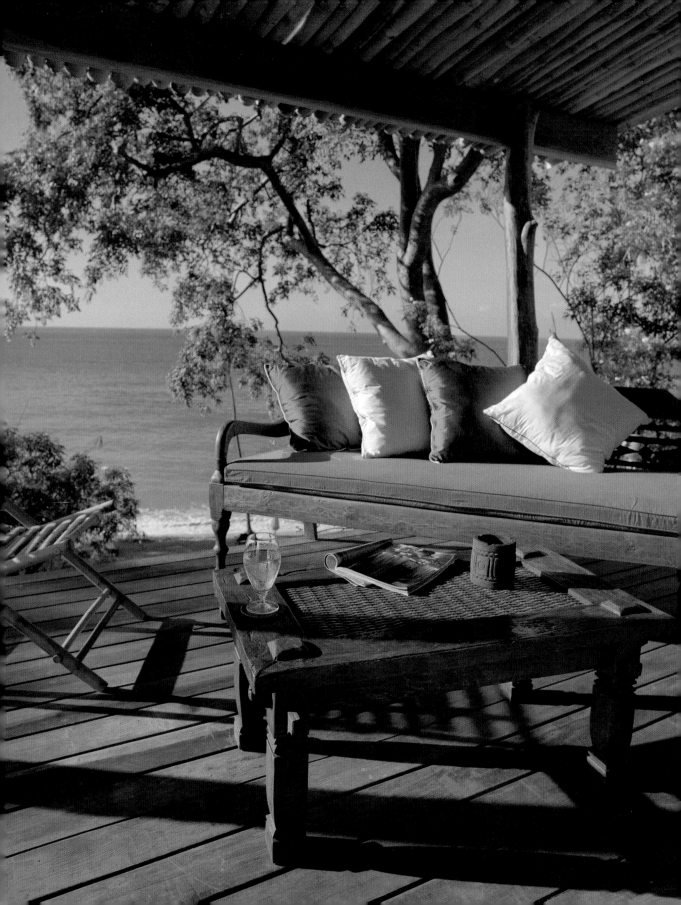

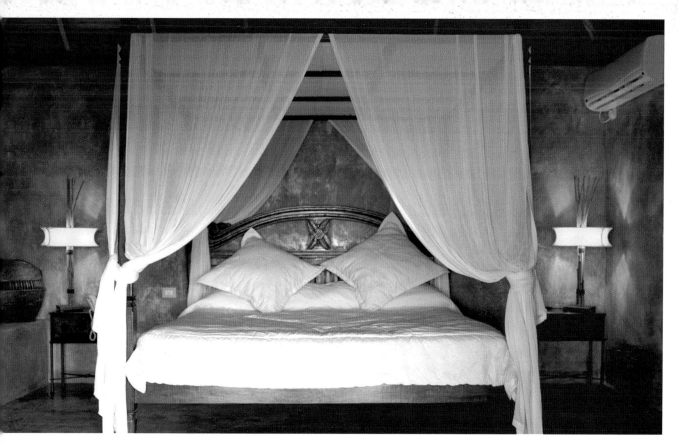

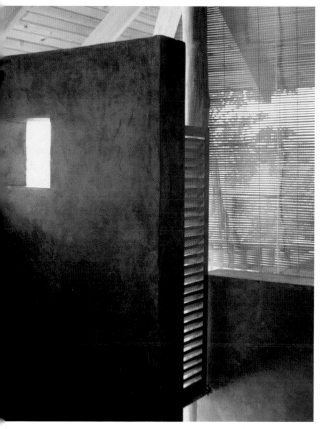

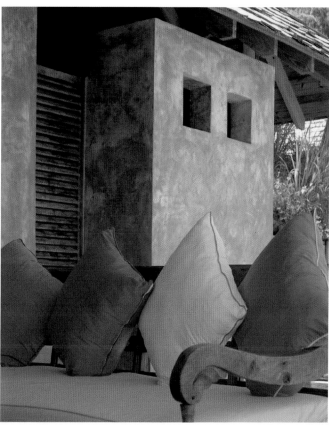

Hotel Miró

Alameda Mazarredo 77 • 48009 Bilbao • Spain • www.mirohotelbilbao.com
2002
Architect: Carmen Abad • www.carmenabad.com
Interior Designers: Antonio Miró • www.antoniomiro.com,
Pilar Líbano
Photos: Joserra Santamaría

Designed by Antonio Miró but named after the famous Spanish artist, Joan Miró, the hotel showcases the work of local artists. Dark wool carpets and Markina marble bathrooms contrast the minimal pale beige guestroom interiors where curtaining is used with dramatic effect.

Das von Antonio Miró entworfene, aber nach dem berühmten spanischen Künstler Joan Miró benannte Hotel zeigt die Arbeit ortsansässiger Künstler. Dunkle Wollteppiche und Badezimmer aus Markina-Marmor bilden einen Kontrast zu der minimalistischen, blass beigefarbenen Ausstattung der Hotelzimmer, in denen die Vorhänge für einen dramatischen Effekt sorgen.

Créé par Antonio Miró mais nommé d'après le fameux artiste espagnol Joan Miró, l'hôtel présente les œuvres des artistes locaux. Des tapis de laine sombres et des salles de bains en marbre de Markina contrastent avec les aménagements minimalistes beige pâle des chambres, dans lesquelles les rideaux sont utilisés pour obtenir des effets dramatiques.

Este hotel, diseñado por Antonio Miró pero que lleva el nombre del famoso pintor español Joan Miró, muestra el trabajo de artistas locales. Las alfombras de lana oscuras y los cuartos de baño de mármol de Marquina contrastan con la decoración minimalista color beige pálido de las habitaciones. Las cortinas aportan un efecto dramático al conjunto.

Concepito da Antonio Miró, ma con il nome del famoso artista spagnolo, Joan Miró, questo hotel mette in mostra il lavoro degli artisti locali. Tappeti di lana scura e bagni in marmo Markina contrastano con gli interni minimalistici delle camere per gli ospiti in beige pallido dove le tende sono usate per creare un effetto drammatico.

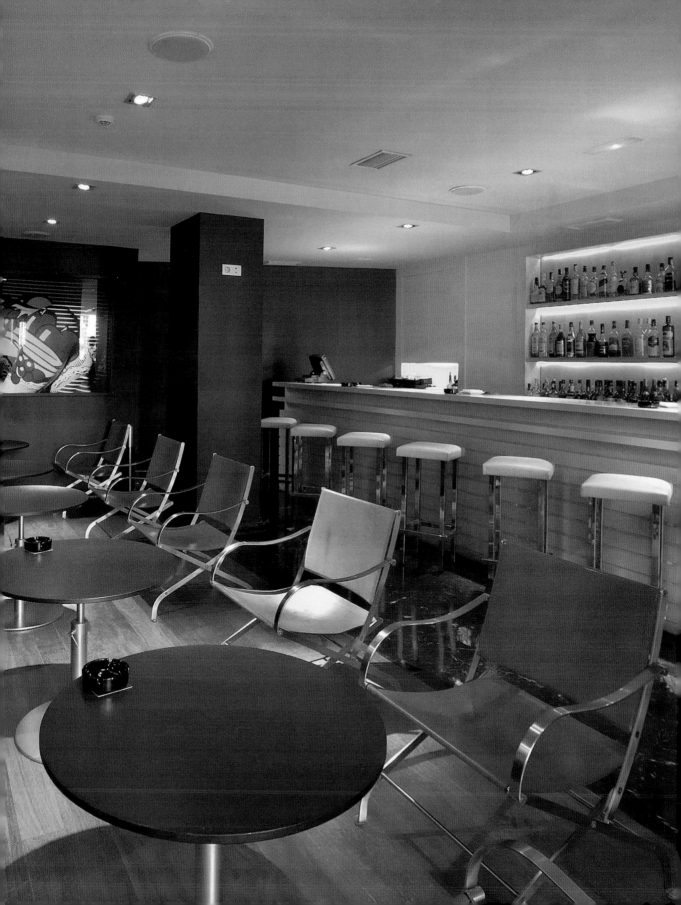

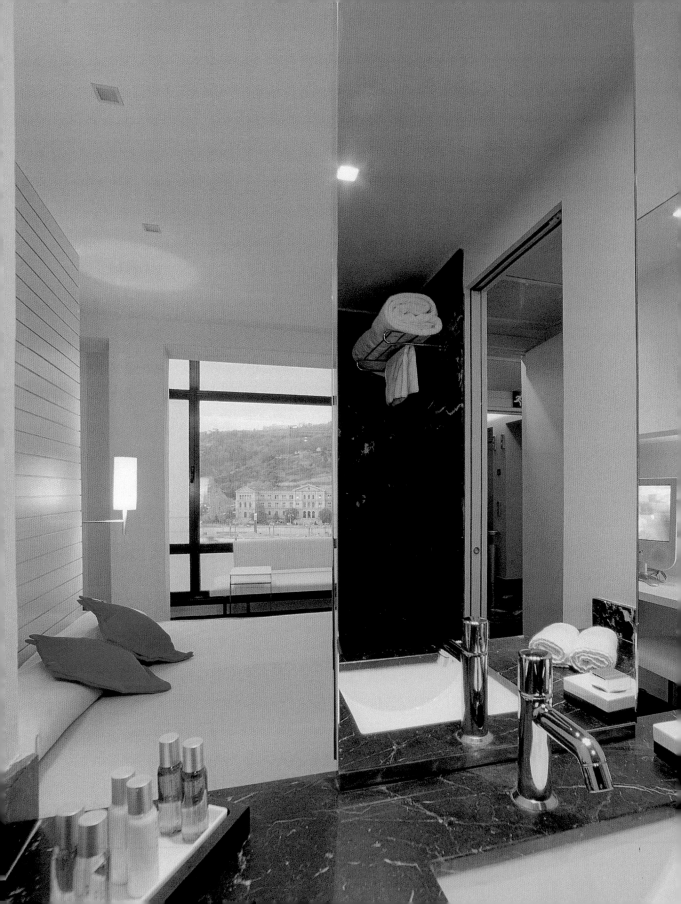

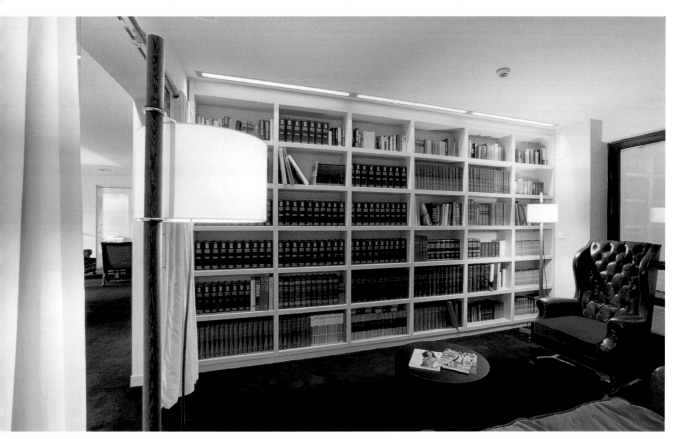

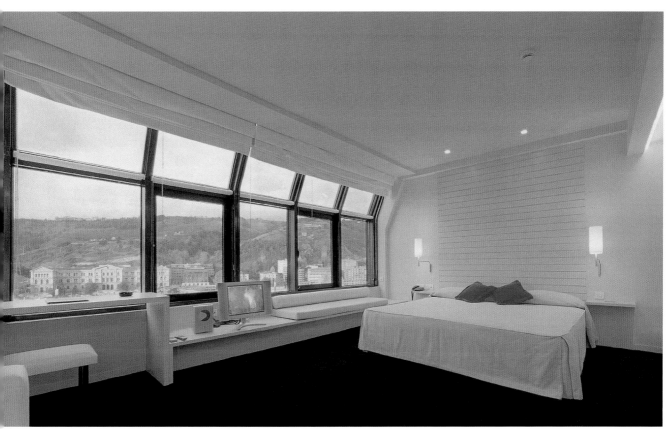

The Morrison

Ormond Quay • Dublin 1 • Ireland • www.morrisonhotel.ie

1999
John Rocha
Photos: courtesy The Morrison

 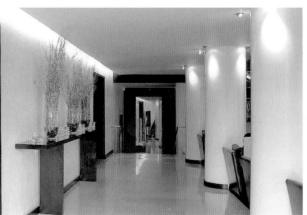

An elegant Georgian façade overlooking the River Liffey hides the sharply sophisticated interiors by locally based designer Rocha. Muted colors and Feng Shui curves are joined by splashes of color—cushions and artwork—to provide the pizazz.

Eine elegante georgianische Fassade über dem Fluss Liffey verbirgt die sehr anspruchsvolle Innenausstattung des ortsansässigen Designers Rocha. Ruhige Farbtöne und Feng-Shui-Bögen werden mit Farbakzenten durch Kissen und Kunstwerke verbunden, um so ein gewisses Flair zu erzeugen.

Une élégante façade géorgienne surplombant la rivière Liffey dissimile les intérieurs hautement sophistiqués créés par le designer local Rocha. Des teintes douces et des courbes Feng Shui sont côtoyées par les taches de couleur des coussins et des œuvres d'art pour obtenir un style pizazz.

Esta elegante fachada de estilo georgiano sobre el río Liffey esconde la sobresaliente decoración interior del diseñador Rocha, residente en el mismo lugar. Los colores tenues y los arcos feng shui se combinan con los colores de los cojines y las obras de arte, produciendo así un ambiente pintoresco.

Un'elegante facciata Georgiana sopra il fiume Liffey nasconde gli interni molto sofisticati del designer locale Rocha. Colori attutiti e angoli di feng shui vengono raggiunti da spruzzi di colore dei cuscini e lavori d'arte per creare un tocco di fascino.

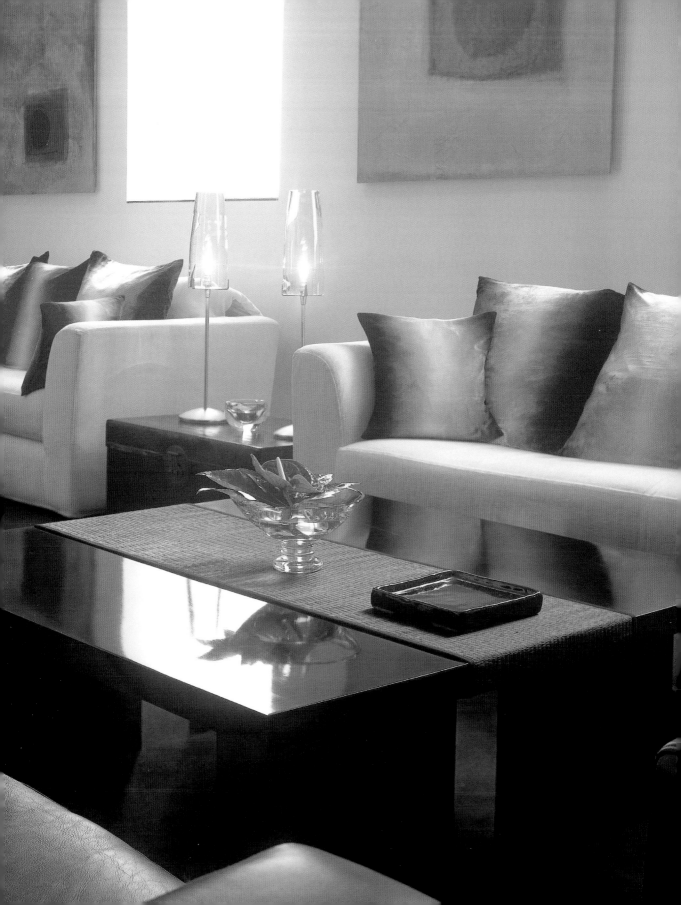

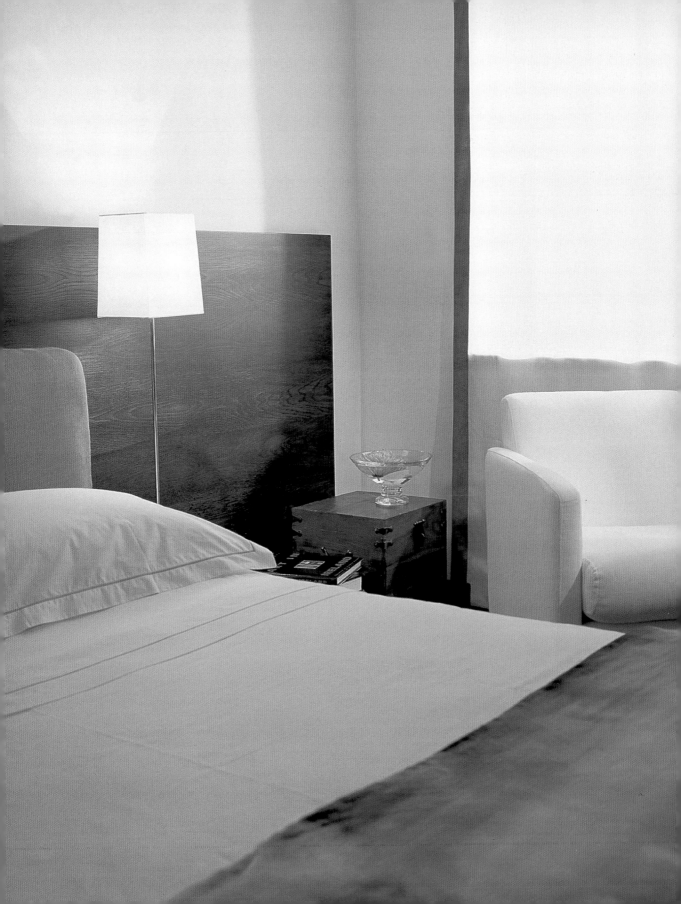

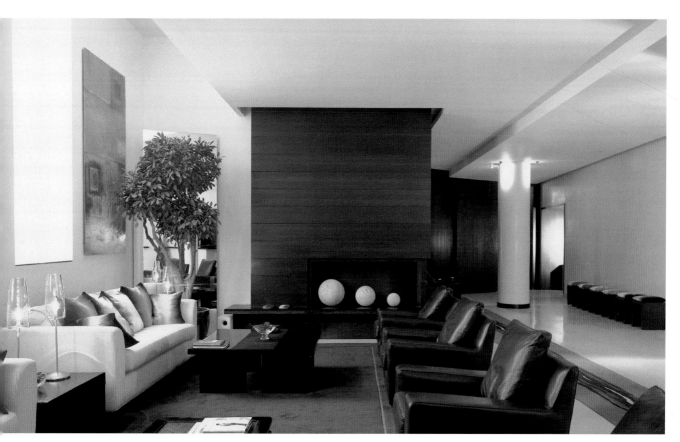

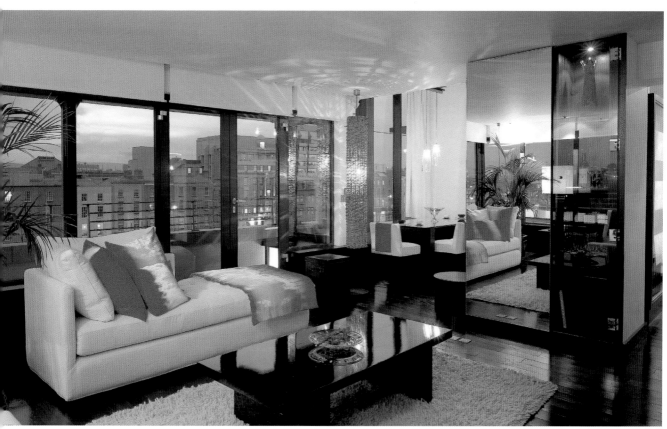

Hôtel du Petit Moulin

29-31, rue du Poitou • 75003 Paris • France • www.paris-hotel-petitmoulin.com

2005
Christian Lacroix
Photos: Roland Bauer

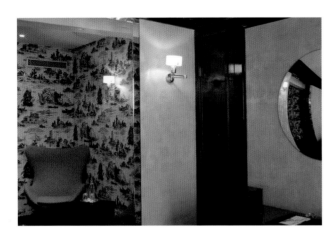 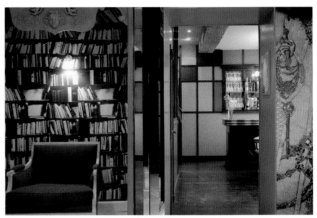

The oldest boulangerie in Paris has become a couture creation of Christian Lacroix, "a chance to build a décor". The hotel is a busy and colorful marriage of patterning, aquarelles of Lacroix's sketches, textures and ornamentation amongst the exposed original timbers.

Die älteste Boulangerie in Paris ist zu einer Modekreation von Christian Lacroix geworden, der darin eine Chance sah, „ein Dekor zu erbauen". Das Hotel ist eine lebhafte und farbenfrohe Verbindung von Mustern, Aquarellen von Lacroix' Skizzen, Texturen und Verzierungen inmitten des frei liegenden Originalfachwerks.

La plus ancienne boulangerie de Paris est devenue une création de couture de Christian Lacroix, « l'opportunité de créer un décor ». L'hôtel est un mariage actif et coloré de dessins de tissus, d'aquarelles des croquis de Lacroix, de textures et d'ornements dispersés parmi les colombages d'origine.

La panadería más antigua de París se ha convertido en una creación de Christian Lacroix, "una oportunidad para crear un decorado". El hotel muestra una combinación vivaz y colorida de muestras, acuarelas de los bocetos de Lacroix, texturas y adornos en medio del entramado original.

La più vecchia panetteria di Parigi si è trasformata in una creazione di moda di Christian Lacroix, "una chance per creare una decorazione". L'hotel è un matrimonio impegnativo e colorato di modelli, acquarelli delle bozze di Lacroix, tessuti e ornamenti tra i tralicci.

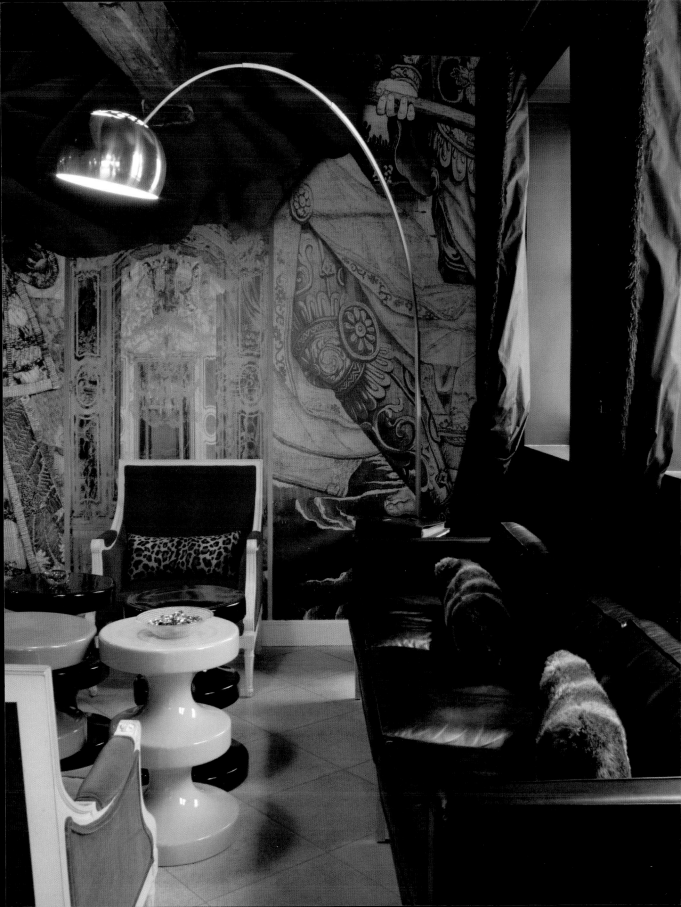

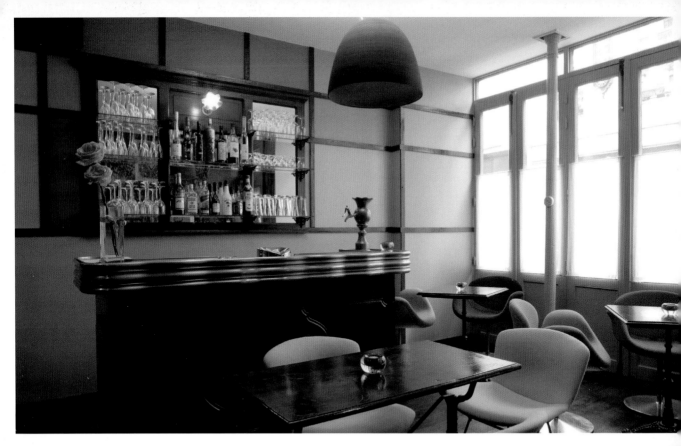

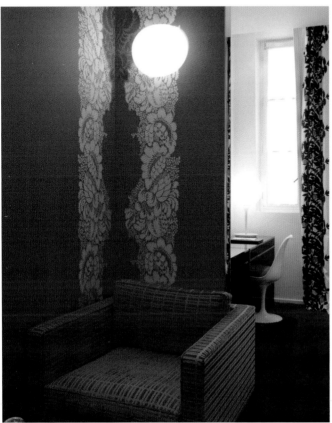

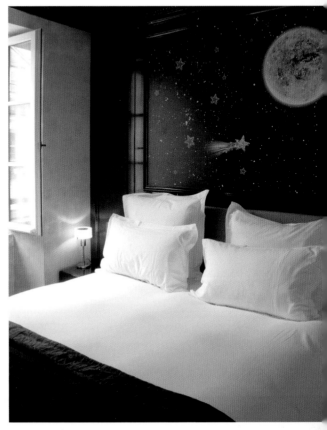

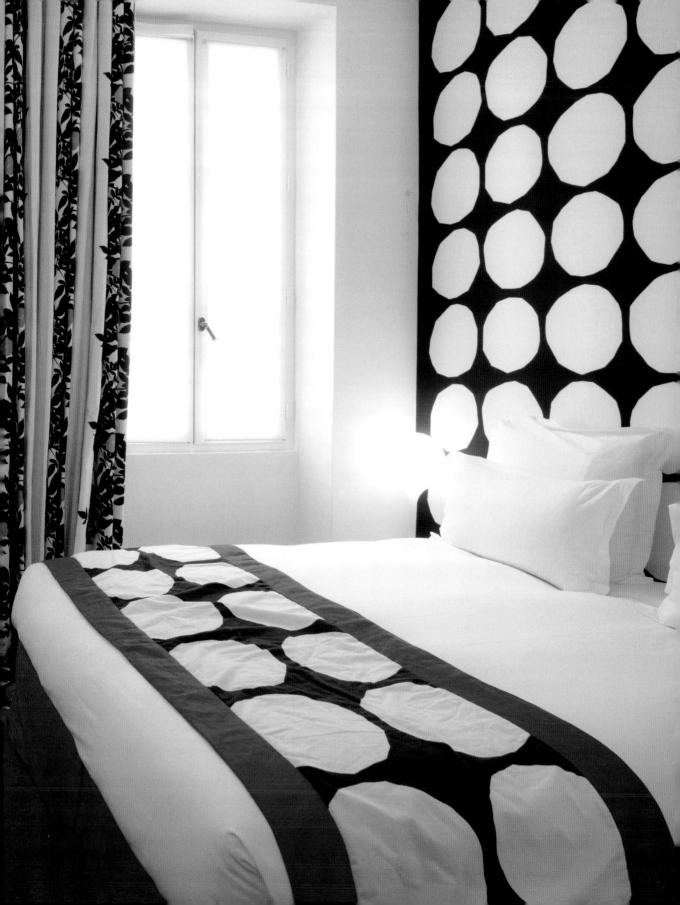

Riviera Golf Club

Via Conca Nuova 1236 • 47842 San Giovanni in Marignano (RN) • Italy • www.rivieragolf.it

2004

Marco Gaudenzi

Photos: courtesy Riviera Golf Resort

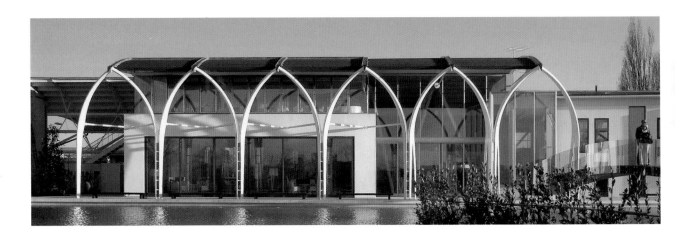

Paolo Gerani has audaciously moved the eclectic world of Iceberg into the hospitality arena with this hotel, golf course and spa. The 32 suites, linked by an innovative design aesthetic, reflect the differing aspirations of the 15 international designers.

Paolo Gerani hat die eklektische Welt von Iceberg mit diesem Hotel, Golfplatz und Wellness-Center im Bereich der Gastfreundschaft angesiedelt. Die 32 Suiten, die durch innovatives Design verbunden sind, spiegeln die unterschiedlichen Bestrebungen der 15 internationalen Designer wider.

Avec cet hôtel, son terrain de golf et son Spa, Paolo Gerani a audacieusement déplacé le monde éclectique d'Iceberg dans une arène hospitalière. Les 32 suites, liées par un design esthétique innovant, reflètent les aspirations divergentes des 15 créateurs internationaux.

Con este hotel, el campo de golf y el centro de wellness, Paolo Gerani ha convertido el mundo ecléctico de Iceberg en hospitalidad. Las 32 suites, que tienen en común una estética innovativa, reflejan las aspiraciones de los 15 diseñadores internacionales.

Paolo Gerani ha audacemente mosso il mondo eclettico degli Iceberg in una zona d'ospitalità in questo hotel, campo da golf e spa. Le 32 suite, collegate da un'estetica di design innovative, riflettono le diverse aspirazioni dei 15 designer internazionali.

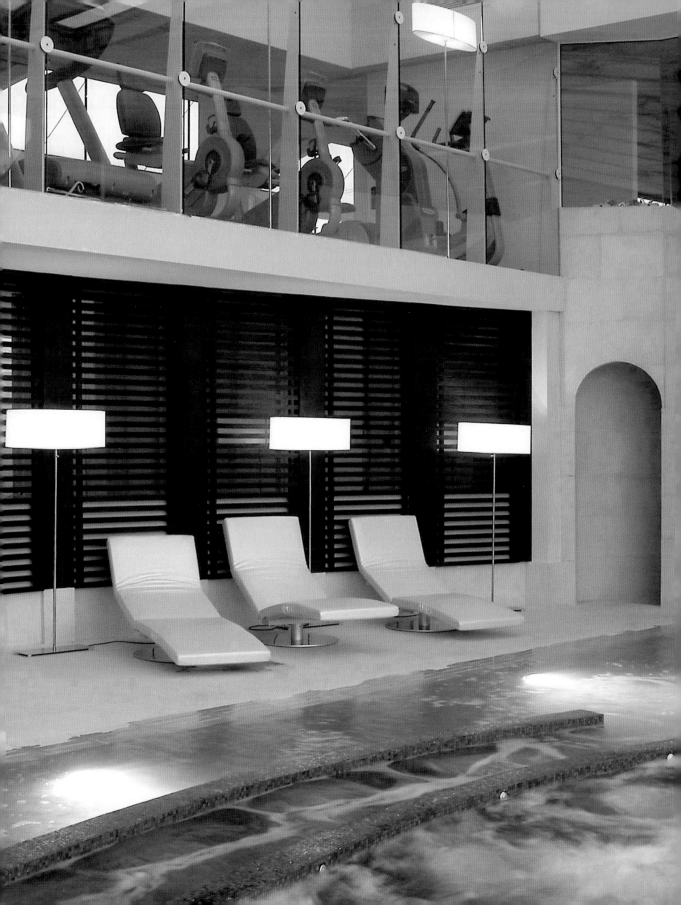

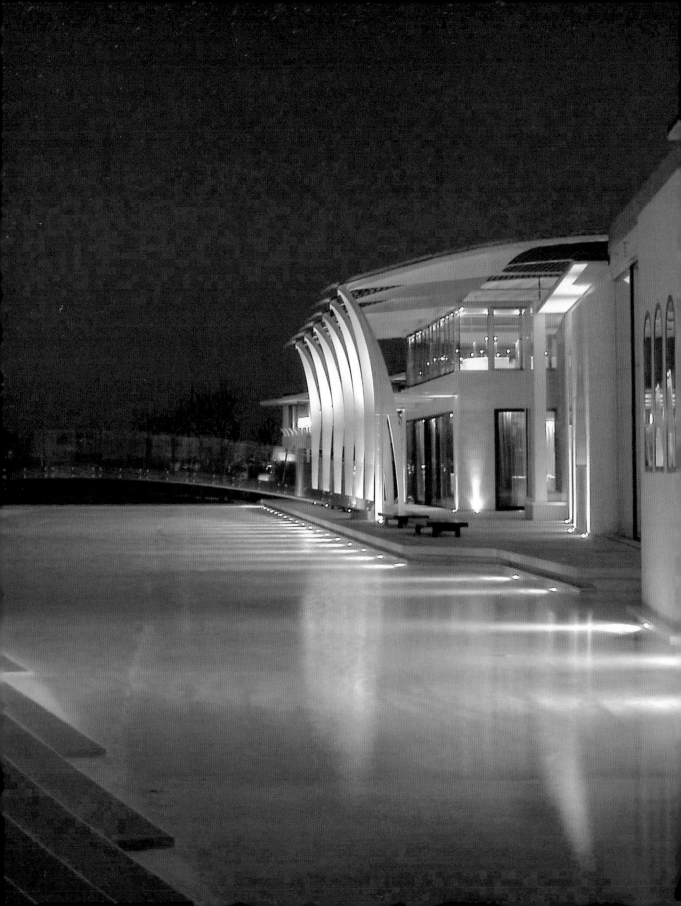

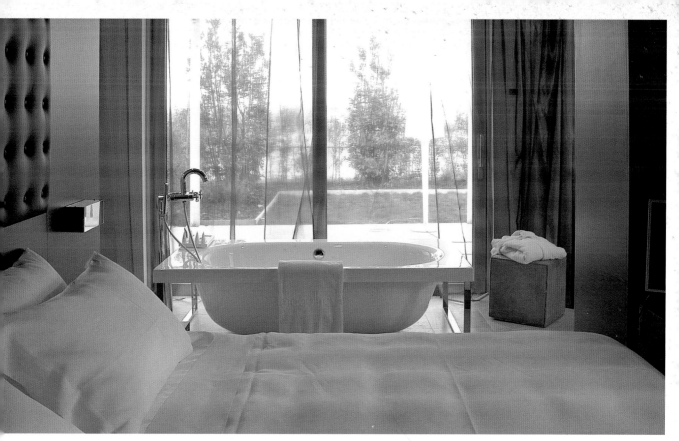

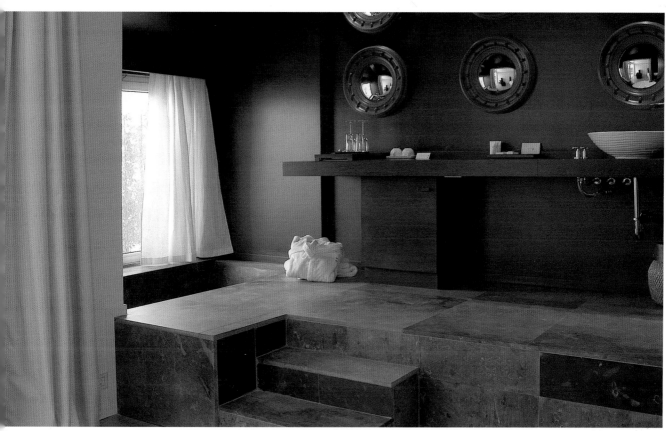

Fashion Suites at Royal Windsor Hotel Grand Place

5 Rue Duquesnoy • 1000 Brussels • Belgium • www.royalwindsorbrussels.com

2004-2006

Jean-Paul Knott, Mademoiselle Lucien, Marina Yee, Gerald Watelet, Haider Ackermann, Pascale Kervan, Nina Meert, Romy Smits, Kaat Tilley, Nicolas Woit, Xavier Delcour, Christian Wijnants
Photos: Jean-Pierre Gabriel, courtesy Royal Windsor Hotel Grand Place

With laudable vision one of Brussels' Grand Dame hotels commissioned twelve Belgian fashion designers to give the couture treatment to a series of corner suites. The curvaceous spiral banquette of Marina Yee's suite contrasts with the oriental art deco vision of Mademoiselle Lucien Couture.

Eine löbliche Zukunftsvision stellt der Auftrag einer Grand Dame unter den Brüsseler Hotels an zwölf belgische Modedesigner dar, einer Reihe von Ecksuiten ein modisches Erscheinungsbild zu geben. Das kurvenreiche, spiralförmige Sofa in der Suite von Marina Yee steht im Kontrast zum orientalischen Art-déco-Design von Mademoiselle Lucien Couture.

Avec une vision louable, l'une des Grandes Dames parmi les hôtels bruxellois a chargé douze créateurs de mode belges d'appliquer un traitement haute couture à une série de suites d'angle. La banquette spirale de la suite aménagée par Marina Yee contraste avec la vision de décoration Art Déco orientale de Mademoiselle Lucien Couture.

Con una visión de futuro admirable, la gran dama del sector hotelero bruselense encargó a doce diseñadores belgas darle una apariencia acorde a la moda a una serie de suites que hacen esquina. El sofá curvado en forma de espiral de la suite de Marina Yee contrasta con el concepto de decoración de art déco oriental de Mademoiselle Lucien Couture.

Una visione futura lodevole rappresenta l'incarico dato da una vera "Grand Dame" tra gli hotel di Bruxelles a dodici designer di moda belgi con l'obiettivo di dare un'apparenza di couture ad una serie di suite ad angolo. Il sofà a spirale e curve della suite di Marina Yee contrasta con la visione orientale decorativa di Mademoiselle Lucien Couture.

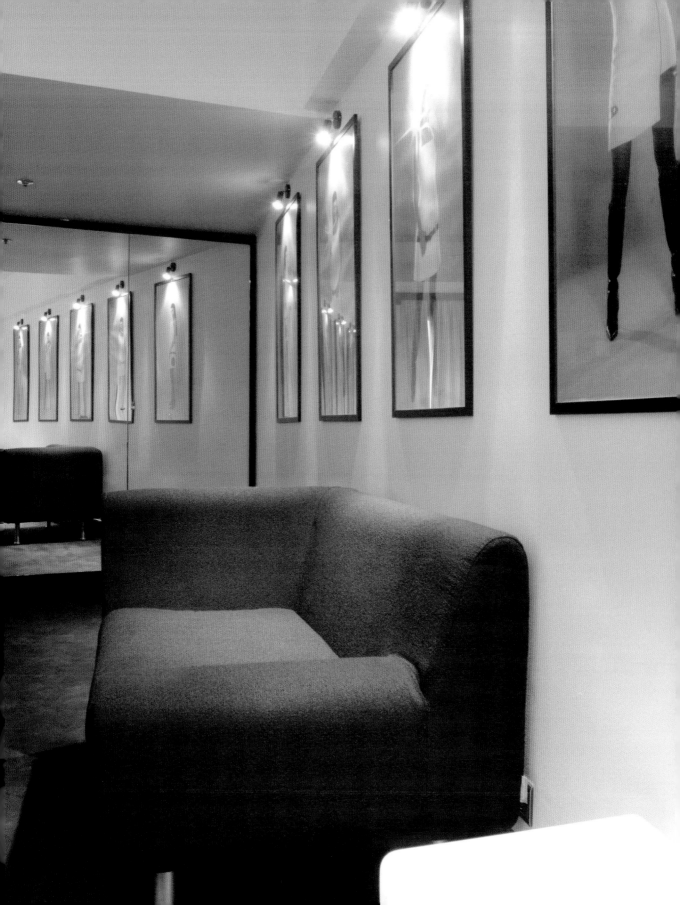

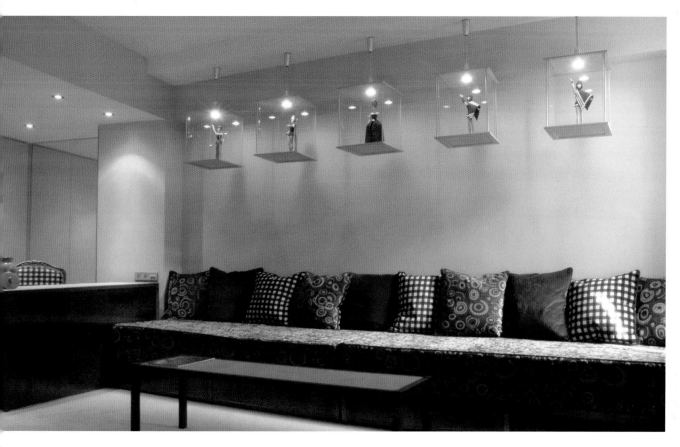

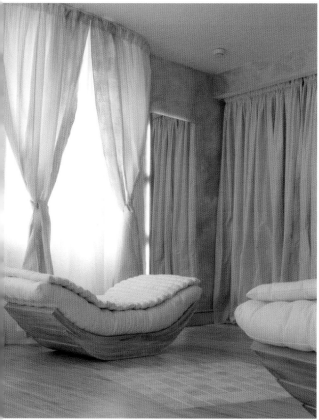

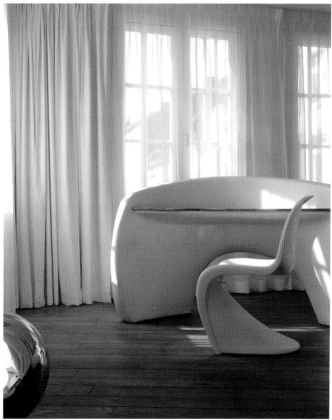

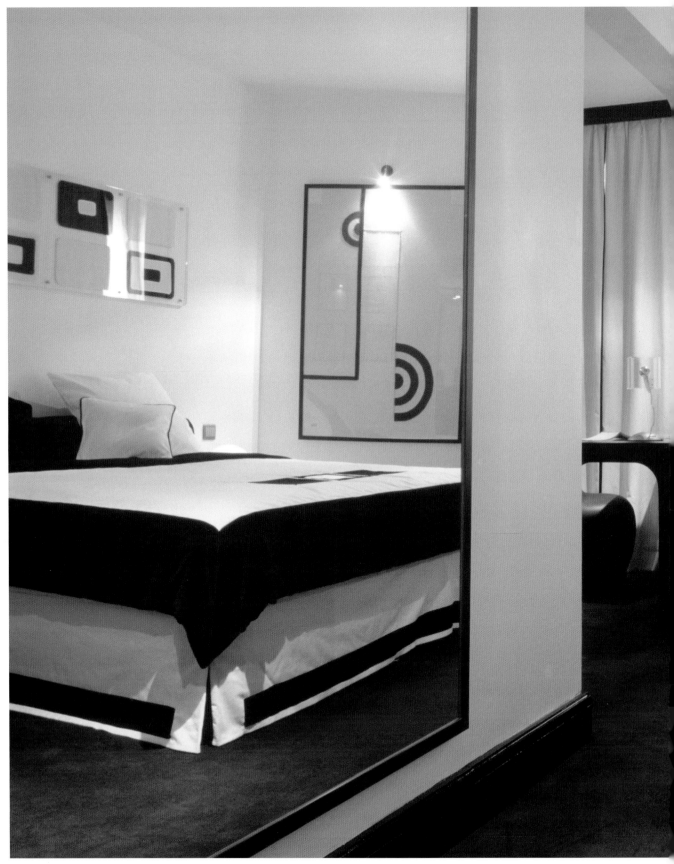

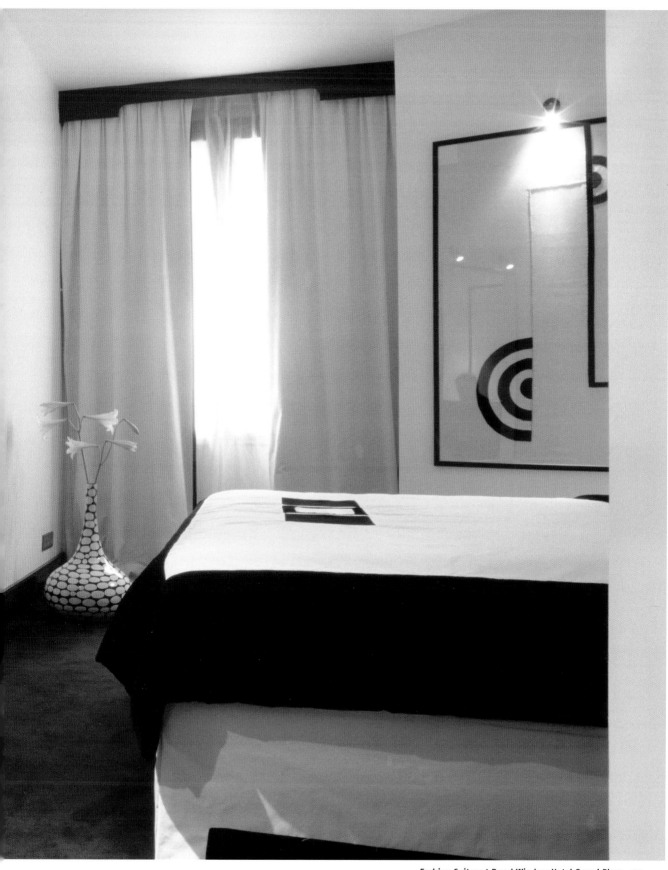

Schlosshotel im Grunewald

Brahmsstraße 10 • 14193 Berlin • Germany • www.schlosshotelberlin.com

Reopening 1994
Architect: German Bestelmeyer
Designer: Karl Lagerfeld
Photos: courtesy Schlosshotel im Grunewald

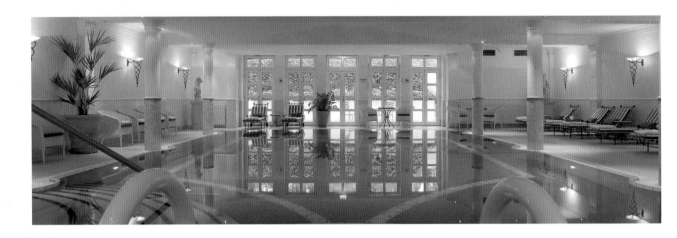

Set amidst parkland, the interiors of this castle-like hotel received a luxurious make-over by Lagerfeld, producing an atmosphere of baronial splendor. Noble grandeur lives on with frescoed ceilings, wood paneling, antiques and even some of Lagerfeld's personal possessions.

Die Innenausstattung dieses mitten in einer Parklandschaft gelegenen Schlosshotels hat eine luxuriöse Bearbeitung durch Lagerfeld erfahren und erzeugt so eine Atmosphäre prunkvollen Glanzes. Auf den mit Fresken versehenen Decken, der Holzvertäfelung, den Antiquitäten und sogar einigen von Lagerfelds persönlichen Besitztümern lebt die edle Grandeur weiter.

Logé dans un parc paysagé, les intérieurs de ce château hôtel on été luxueusement revus par Lagerfeld et produisent une ambiance de splendeur ducale. La noble grandeur se voit dans les plafonds à fresques, les murs habillés de bois, les antiquités et même certains objets personnels de Lagerfeld.

La decoración de interiores de este hotel rodeado de parques ha sido retocada por Lagerfeld, lo que ha dado como resultado un brillo pomposo. La noble grandeza sigue brillando gracias a los techos con frescos, los recubrimientos de madera, las antigüedades e incluso algunos objetos de la colección privada del mismo Lagerfeld.

Situato al centro di una zona parco, gli interni di questo hotel, simile ad un castello, sono stati lussuosamente rifatti da Lagerfeld, creando un'atmosfera di splendore dell'era dei Baroni. La nobile "grandeur" rivive nelle pareti affrescate, pannelli di legno, antichità e addirittura alcuni pezzi di proprietà di Lagerfeld stesso.

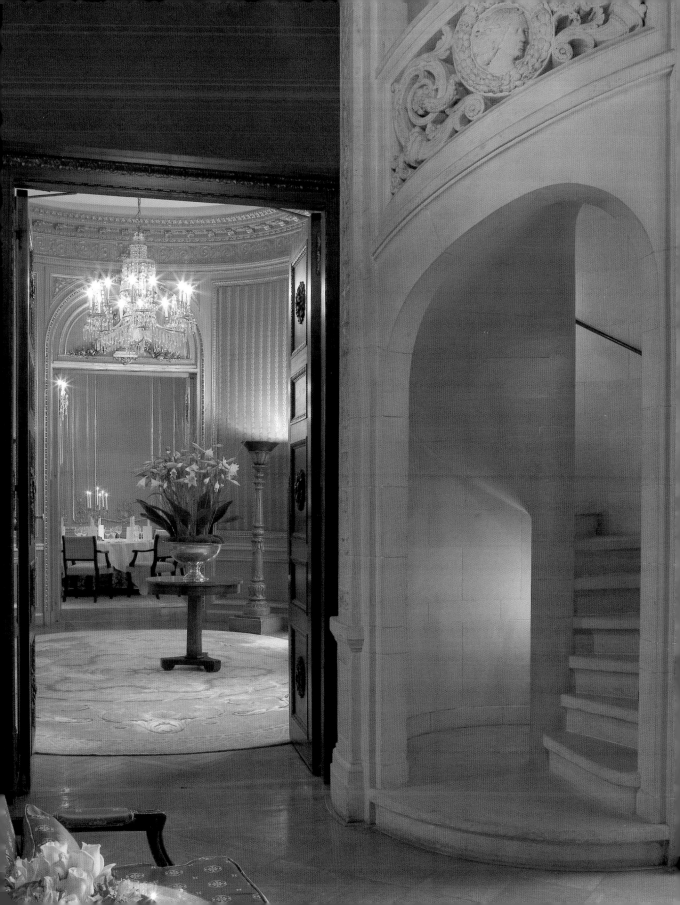

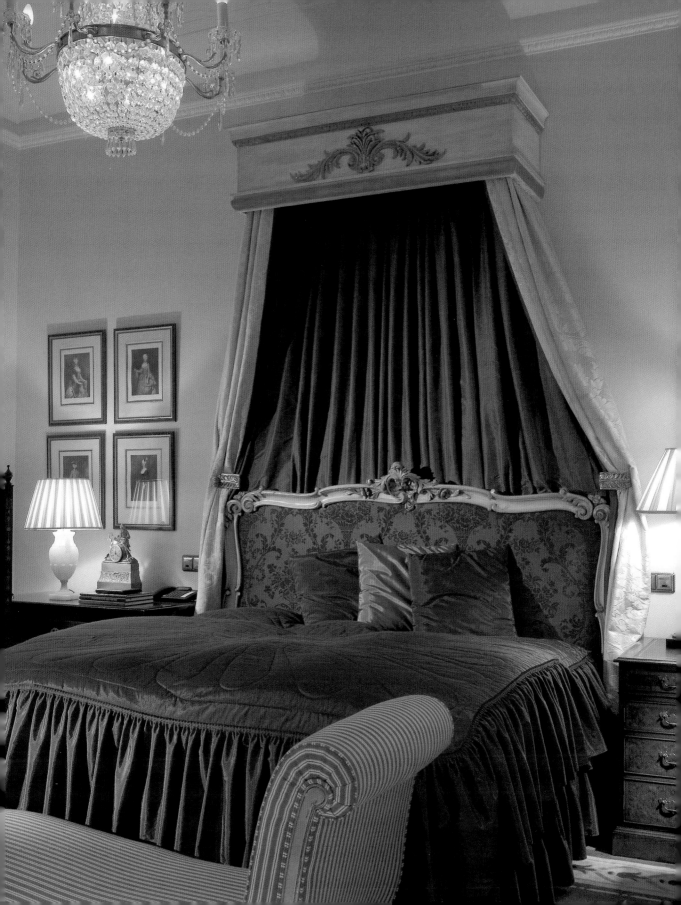

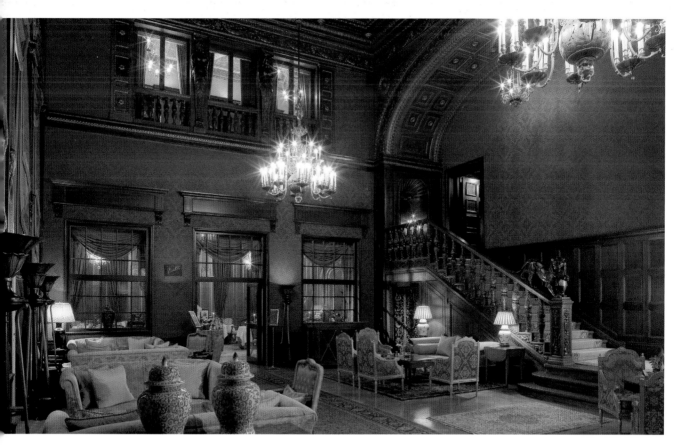

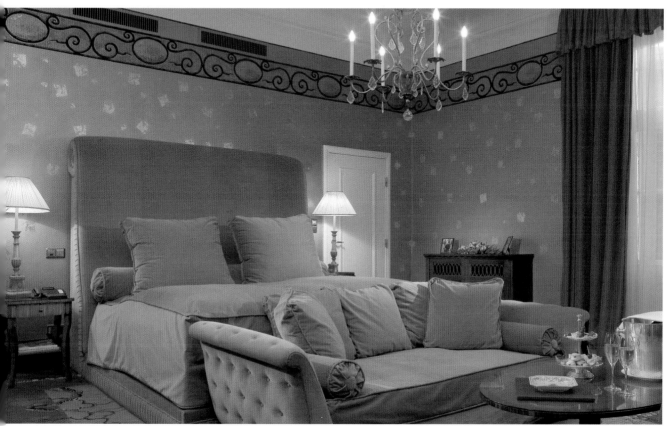

Sixty Hotel

Via Milano 54 • 47838 Riccione • Italy • www.sixtyhotel.com

2006

Sixty 63

Photos: Luca Perticone, courtesy Sixty Hotel Communication & PR

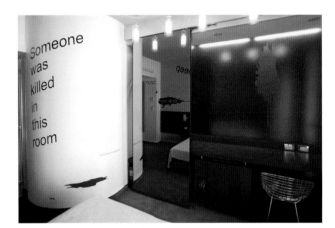
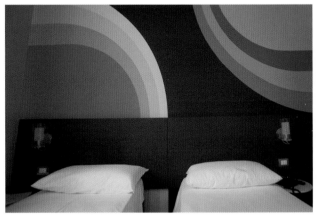

High sheen finishes of plastic, glass and steel, amusing pop graphics and a humorous façade lend a youthful air of exuberance to this hotel from the founders of the Miss Sixty fashion label. The interiors are the work of over 30 young designers, curated by Wichy Hassan.

Mit schimmernden Plastikoberflächen, Glas und Stahl, amüsanten Popgrafiken und einer humorvollen Fassade verleihen die Gründer der Marke Miss Sixty diesem Hotel eine Atmosphäre jugendlichen Überschwangs. Die Innenausstattung ist das Werk von über 30 jungen Designern unter der Leitung von Wichy Hassan.

Des finitions haute brillance en plastique, en verre et en acier, des graphismes pop amusants et une façade pleine d'humour donnent un air d'exubérance jeune à cet hôtel des fondateurs de la marque de mode Miss Sixty. L'intérieur a été réalisé par plus de 30 jeunes créateurs, présentés par Wichy Hassan.

Los fundadores de la marca Miss Sixty le dan a este hotel un toque de desenfreno juvenil mediante las superficies de plástico resplandecientes, el cristal y el acero, el divertido arte gráfico de tendencia Pop y la cómica fachada. Wichy Hassan supervisó la decoración de interiores, que es obra de más de 30 jóvenes diseñadores.

Finiture che risplendono in plastica, vetro e acciaio, grafiche pop divertenti e facciate umoristiche danno un tono di giovane esuberanza a questo hotel dei fondatori della marca di moda Miss Sixty. Gli interni rappresentano il lavoro di più di 30 giovani designer, a cura di Wichy Hassan.

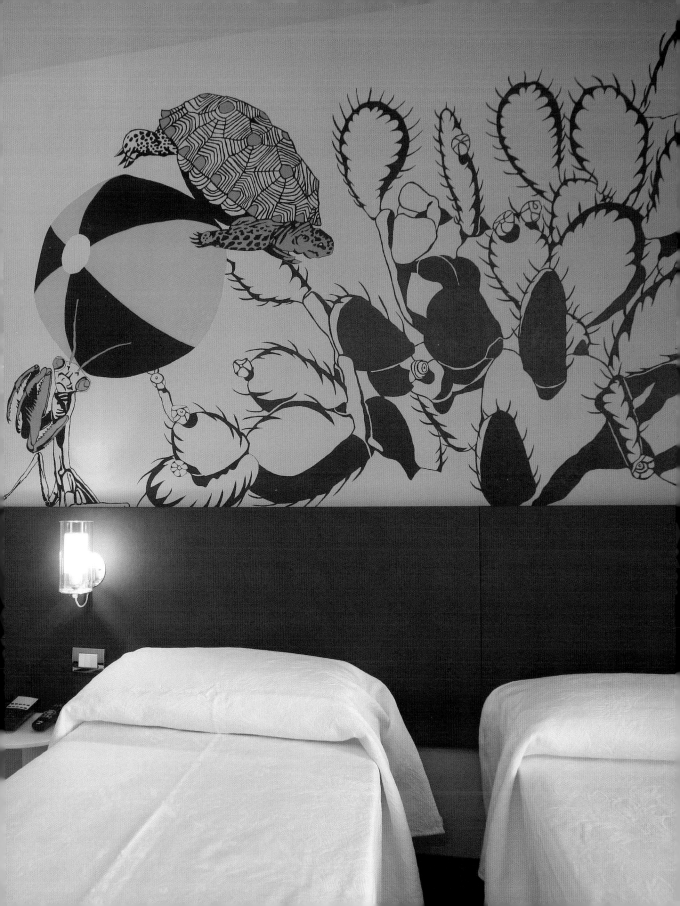

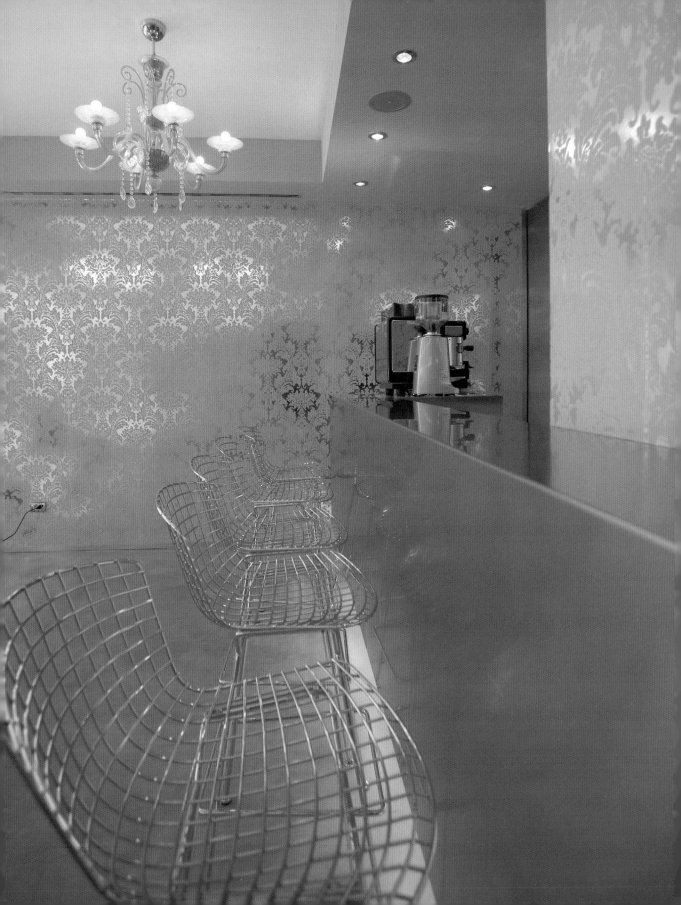

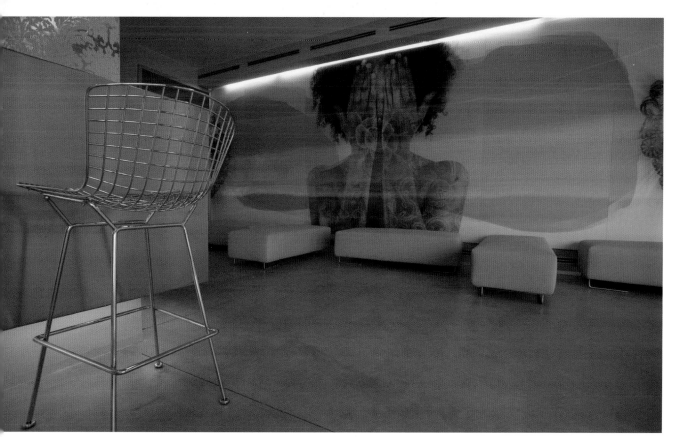

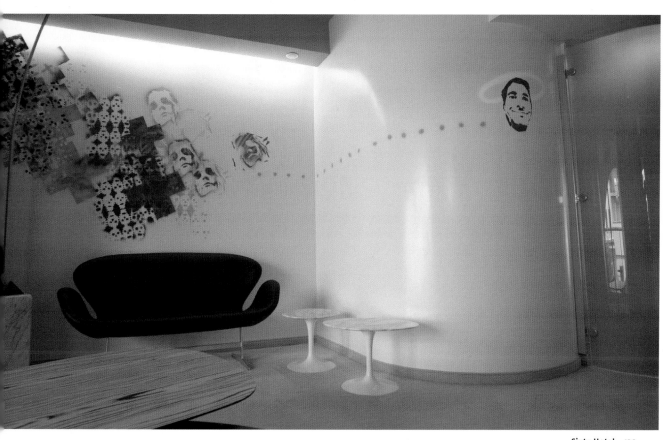

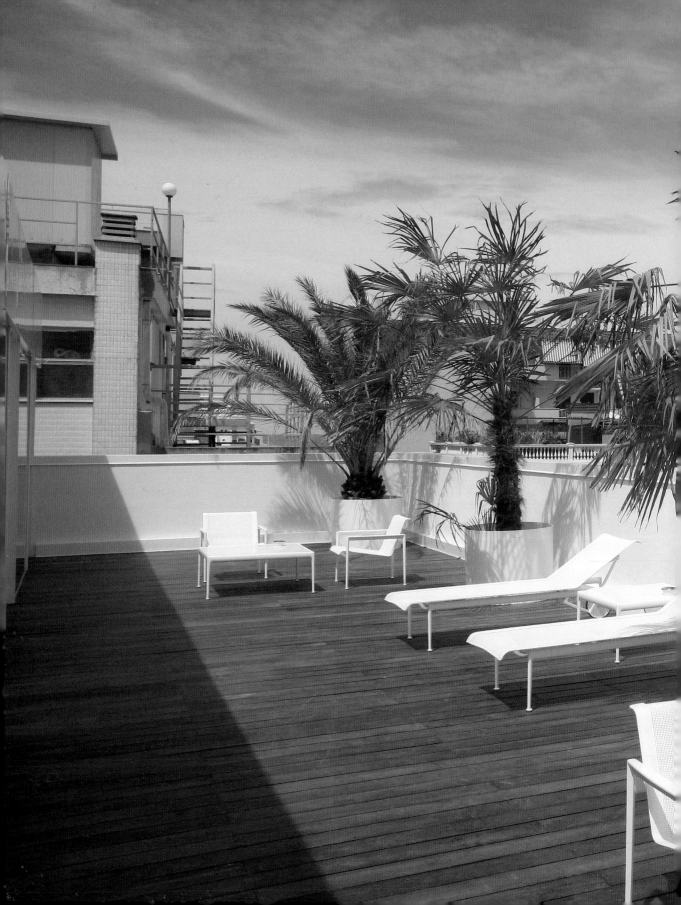

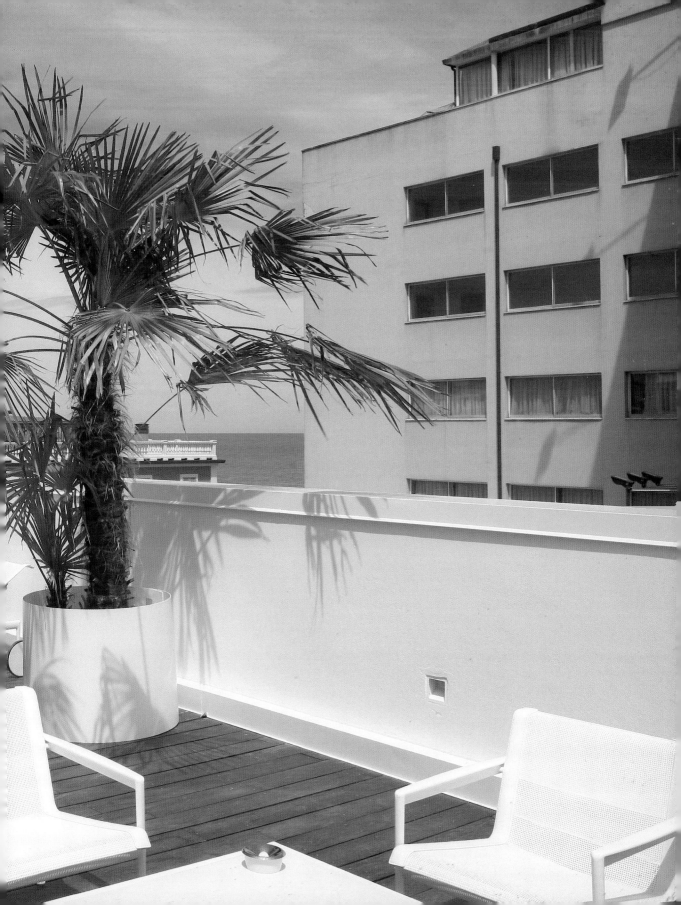

Straf

Via San Raffaele 3 • 20121 Milan • Italy • www.straf.it

2003
Vincenzo de Cotiis
Photos: STUDIO NEXT, Leila Palermo

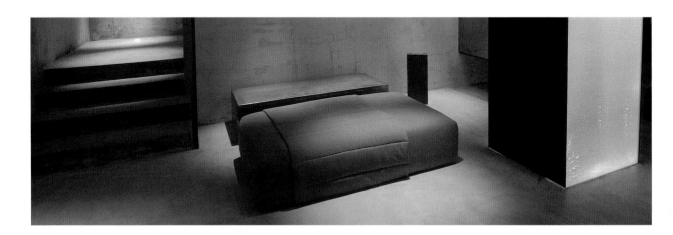

The re-utilization of second hand materials is a trademark of Vincenzo de Cotiis fashion work. Uncompromising metals and raw concrete are used to portray almost experimental interiors. Each room is individually decorated with its own art installation.

Die Wiederverwendung von Materialien aus zweiter Hand ist ein Markenzeichen der Modearbeiten von Vincenzo de Cotiis. Metalle und roher Beton kreieren nahezu experimentelle Interieurs. Jedes Zimmer ist individuell mit seiner eigenen Kunstinstallation ausgestattet.

L'utilisation de matériaux d'occasion est l'un des emblèmes des créations de mode de Vincenzo de Cotiis. Du métal et du béton brut sont utilisés pour faire le portrait d'intérieurs presque expérimentaux. Chaque chambre est décorée individuellement avec sa propre installation d'art.

La reutilización de materiales de segunda mano es una marca comercial de los diseños de moda de Vincenzo de Cotiis. Los metales y el hormigón en crudo sirven para retratar una vida interior casi experimental. Cada una de las habitaciones está peculiarmente diseñada y posee sus propias instalaciones artísticas.

La riutilizzazione di materiali di seconda mano rappresenta una marca del lavoro di moda di Vincenzo de Cotiis. Metalli e calcestruzzo grezzo vengono usati per rappresentare degli interni principalmente in maniera sperimentale. Ogni camera è arredata in maniera individuale secondo la propria visione dell'arte.

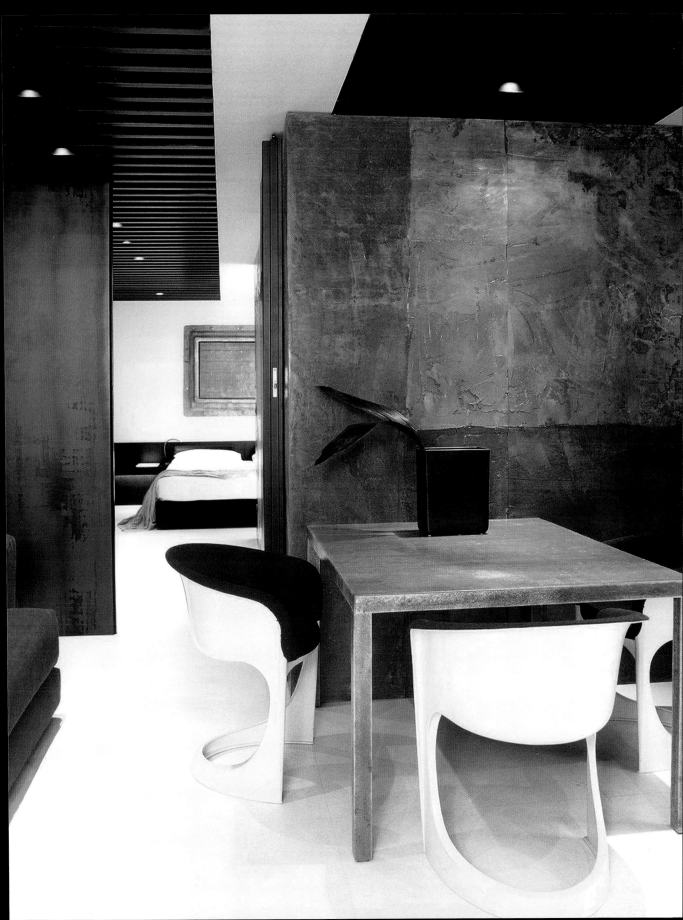

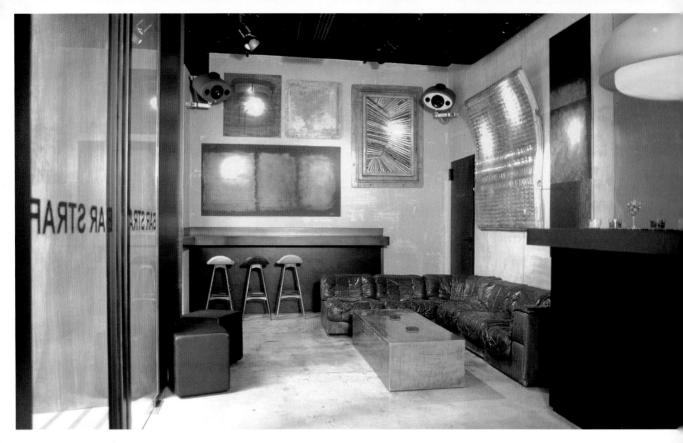

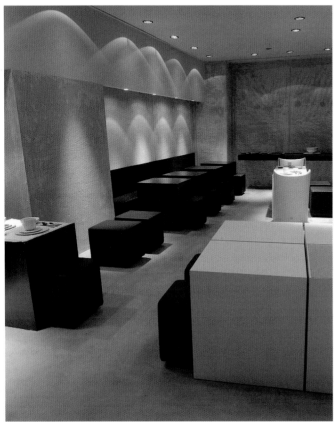

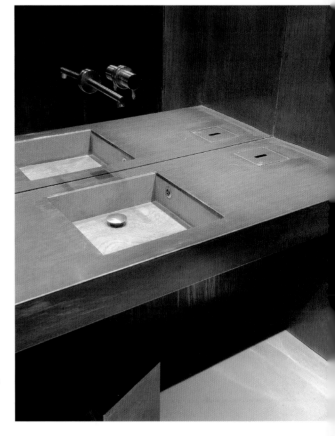

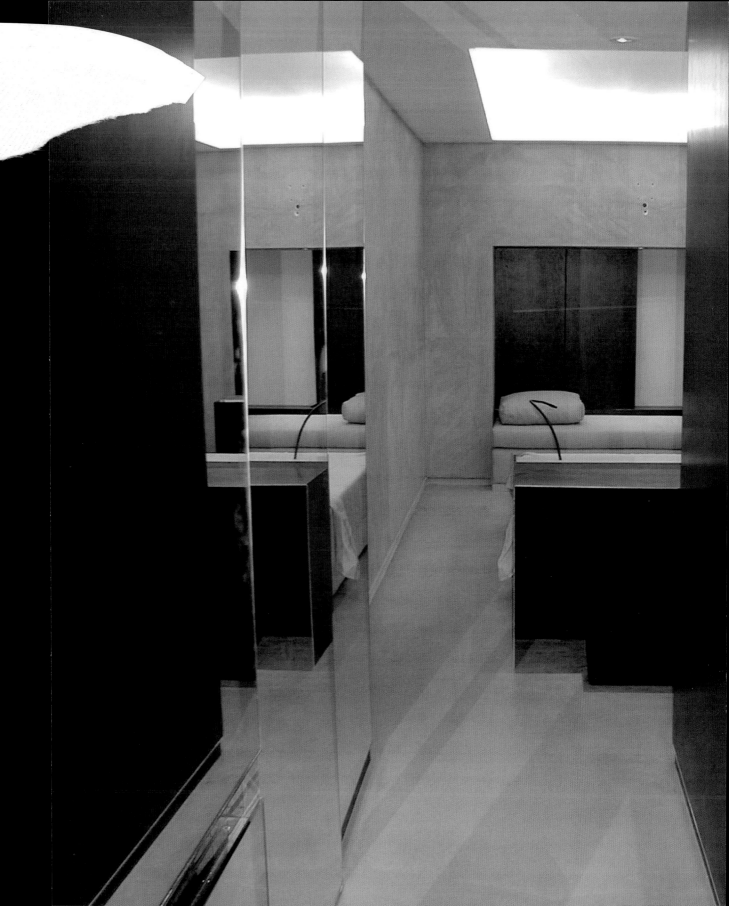